WILD WOMEN
of PRESCOTT, ARIZONA

WILD WOMEN of PRESCOTT, ARIZONA

Jan MacKell Collins

THE History PRESS

Published by The History Press
Charleston, SC 29403
www.historypress.net

Copyright © 2015 by Jan MacKell Collins
All rights reserved

Front cover images, clockwise from top left: courtesy Gabriell Wiley estate; courtesy Tombstone Museum; courtesy Jan MacKell Collins; courtesy Jan MacKell Collins; courtesy Gabriell Wiley estate; courtesy Jan MacKell Collins.

First published 2015

Manufactured in the United States

ISBN 978.1.62619.863.0

Library of Congress Control Number: 2014959947

Notice: The information in this book is true and complete to the best of our knowledge. It is offered without guarantee on the part of the author or The History Press. The author and The History Press disclaim all liability in connection with the use of this book.

All rights reserved. No part of this book may be reproduced or transmitted in any form whatsoever without prior written permission from the publisher except in the case of brief quotations embodied in critical articles and reviews.

For Mom. Here we go again.

Contents

Acknowledgements 9
Introduction 11

1. Prescott, Maiden City of Arizona 15
2. A Tough Life 31
3. Murder in the Red-Light District 45
4. Ladies of the Line 57
5. Queens of the Row 71
6. The Strange Fate of Mollie Sheppard 85
7. Lida Winchell, From Rags to Riches to Rags 95
8. In Defense of Gabriell Dollie Wiley 109
9. The Law Is the Law 131
10. A Look Back 149

Notes 159
Bibliography 171
About the Author 175

Acknowledgements

A number of people have worked tirelessly with me to make sure this book is the best it can be. At the forefront is Christen Thompson, my editor at The History Press, whose patience, professionalism and thoroughness have truly been a gift. Another thanks goes to Jaime Muehl, who gave me additional insight during the editing process. I would also like to thank Shelly Dudley, the lovely proprietress of Guidon Books in Scottsdale, Arizona, for introducing me to The History Press and its wonderful line of history books.

My research would not have been so complete without the help of John Brusco and John and Mary Jo Murray, who shared their information and stories about Gabe "Dollie" Wiley. The same goes for Tim Wellesley, who has conversed with me for years about Eliza Jane Crumley's family in Colorado, Arizona and Nevada. Prescott historians Parker Anderson, Brad Courtney, Ken Edwards, Elisabeth Ruffner, Patricia Ireland Smith, the staff at Sharlot Hall Museum Library & Archives and librarian Scott Anderson were all of immense help. I also truly appreciate the quick assistance of Laura Palma-Blandford, archivist at the Arizona State Library. Wyatt and Terry Earp and their webmaster, Dale Schmidt, have been helpful on this and so many other projects. And thank you to Bob Boze Bell and Meghan Saar at *True West* magazine for publishing my ongoing tales of wanton women.

I would not have had such a great inventory of images to choose from were it not for the four generations of my family who left behind hundreds of photos for me and future family members to enjoy. Also, a big thank-you goes to Professor Jay Moynahan, one of my biggest

Acknowledgements

supporters, who always has "one more picture" for me to use. Miss Lydia Gray of California was also of immense help, as was Al Bossence of the "Bayfield Bunch" in Congress.

My gratitude would not be complete without thanking my beautiful husband and best friend, Corey, for putting up with me and letting me write in my pajamas all day.

INTRODUCTION

As one of the last states to enter the Union, Arizona remained a raw, rather uncivilized territory between 1863 and 1912. The untamed land lent itself to explorers, miners, ranchers, farmers and others who saw an opportunity to prosper. The growing population also included its share of shady ladies, a staple of the economy in nearly every western town. These wanton women prided themselves in being independent, hardy individuals who weren't afraid to pack their petticoats across rough, barren terrain and set up shop. Their stories range from mild to wild, with plenty of colorful anecdotes in between.

Who were these daring damsels who defied social norms to ply their trade in frontier Arizona? The 1860 United States census, taken just three years before Arizona Territory was formed, listed a number of women who were living in what was then New Mexico Territory. At the time, New Mexico Territory was quite large. The population, which spanned across today's Arizona, New Mexico, a portion of Colorado and part of Nevada, included mostly Mexican women who were locally born.

In 1863, President Abraham Lincoln signed the Organic Act that divided Arizona and New Mexico Territories with a north–south border that is still in place today. The first Arizona territorial census was conducted the following year, revealing a population numbering over 4,500 people. Almost 1,100 of them were female adults and children.[1]

Arizona's military forts, mining camps, whistle-stops and cities grew at an amazing rate. Soldiers of the early frontier forts served as ample clientele

Introduction

for prostitutes during Arizona Territory's formative years. Later, as mining camps grew into towns and towns bloomed into cities, a bevy of soiled doves flocked into these places and set up more permanent bordellos. In time, nearly every town included working girls who conducted business in anything from tents, to tiny one- or two-room adobe or stick-built cribs, to rooms above saloons, to posh parlor houses. Prescott, one of the earliest, wildest and fastest-growing towns in the territory, was no exception.

The census records of the 1800s are among the best resources used to identify prostitutes, but even these failed to identify every known working girl in Prescott. By 1870, the women of the town numbered a mere 108 versus 560 men. The census reveals little else about the ladies, including their marital statuses, unless they were married within that year. In most cases, the occupations of women who worked in the prostitution industry were discreetly left blank. Because the occupations of women who were unemployed or working as housewives were also unidentified in several instances, the true number of women working as prostitutes will never be known.

Not until the 1880 census were more—but not all—women of the underworld in Prescott blatantly identified as prostitutes, "sporting" and "fancy" women, mistresses and madams. The smart prostitute revealed very little about herself and took great pains to disguise her real identity, where she came from and how she made her living. Such details, however, might be revealed in her absence by a roommate, her madam, a nearby business owner or even the census taker, who knew the occupants of the red-light district but was too embarrassed to knock on the doors there. So while girls such as Elizabeth Arbuckle were listed as prostitutes in Prescott during the 1880 census, other women—such as madam Ann Hamilton—were listed only as "keeping house" and by other indiscernible occupations.

Census records also revealed changes in the way the West viewed the prostitution industry over the next twenty years. Though the 1890 census burned up in a fire, it was obvious by 1900 that civilization had started its inevitable creep into Arizona Territory. Wives, families, churches and temperance unions were part of the growing groups in the West. Wayward ladies were forced to tone down their job descriptions to some extent. While blatant racism encouraged identifying Japanese and Chinese prostitutes as such, the Anglo women living next to them or in identified red-light districts claimed to be working as seamstresses, laundresses, milliners and other demure careers that kept them out of the spotlight as "working girls."

From 1900 on, the bad girls of Prescott became largely unidentifiable save for the telltale neighborhoods in which they lived, their skirmishes as

Introduction

reported in newspapers and the legal documents that singled them out. As the city continued growing, the female population had started catching up to the male population by 1910 (2,032 women to 2,711 men). The girls of the row now struggled to prosper while their hometown remained tolerable for the most part. Interestingly, the residents of Prescott seem to have accepted their working girls as they would any other citizens, more so than in many other towns in the West. Everybody knew that sex was for sale along Granite Street, just one block west of Montezuma Street's "Saloon Row." And very few seemed inclined to do much about it.

Historically speaking, however, loose women have always generated an enigmatic history. In a historically untamed place like Arizona, they are hard to track. Prescott was, in fact, so accepting of its shady ladies that, unless they got into trouble and landed in the public eye, tangible records of them are very scarce. Finding them is further complicated by the time-honored tradition of generating folklore and embellishments over time, with a good sprinkling of misguided attempts to brand many a colorful old hotel, saloon or home as a former whorehouse. And although many of Prescott's brazen hussies have a solid place in the state's history, far more have escaped the eyes of historians and quietly faded along a rather dusty trail.

Despite Prescott's ambivalence toward its wayward girls, being a prostitute was still the naughtiest of naughty deeds. The law, the moral majority and a good number of angry wives rarely lost the opportunity to emphasize the evils of being a bad girl. Their efforts were not unwarranted. Prescott newspapers do have stories of wicked women of the past who were not beyond lying, thieving and even murdering as they danced their way through the demimonde. Some crimes are excusable; certain girls were in the business due to the loss, by death or desertion, of a husband. Those who fought and/or killed were often defending their own honor or fighting for their lives during some domestic dispute. But it is no secret that certain prostitutes were truly a bad lot and drank, drugged, danced, fought, killed, stole and sold their bodies solely to appease their own inner demons.

In time, Prescott, along with a number of other communities, officially outlawed prostitution to conform with state laws and the moral element. On the side, however, officials continued to quietly tolerate the red-light districts. The prostitution industry evolved into an underground cash cow of sorts. As immoral as they were, women of the lamplight provided company and entertainment for Arizona's restless soldiers and miners. They were also an excellent source of income for the city coffer, where their fines, high taxes and monthly business fees were deposited on a regular basis. Not

Introduction

surprisingly, required weekly or monthly medical exams were conducted by a city physician, whose salary was supplemented by fees from his patients.

Stories are numerous of illicit ladies in the West who sheltered the homeless; fed the poor; employed the unemployed; contributed to the building of hospitals, schools and churches; and assisted their hometowns with numerous unseen, unappreciated efforts. Arizona was no exception to the kindness of these true "whores with hearts of gold," as the old saying goes. Thus, even though the territorial government outlawed prostitution once and for all in 1907, the law was loosely enforced on behalf of the good-time girls who made Prescott's history even more colorful than it already was.

Some feel that history accounts about prostitution somehow revere the industry's participants as heroes. Others think that revealing the lives of the industry's chief participants further shames them. Along those same lines, there is little doubt that many fallen angels preferred to remain unknown, hoping that their misdeeds would fade with their names into history. They did not want to embarrass their families or even friends who may have known them back when they were "good girls."

Good or bad, the ladies are now long gone, unaware that their humility and courage are often held in esteem by others who enjoy reading about them and many who sympathize with their plight. The shame is mostly gone, too, even if it is often replaced by the romantic notion that all prostitutes' lives were interesting, even fun. In many cases, they were not. True fans of prostitution history recognize that the vast majority of these women gambled everything, at very high risks, for a chance at surviving in a less than perfect world. Their efforts are memorable, at the very least because they served as an integral staple of the economy of the West. No matter their misdeeds, they deserve a second look as an important part of American history. Here are some of their stories.

Chapter 1
PRESCOTT, MAIDEN CITY OF ARIZONA

Aside from the occasional miner who located to the area, Prescott proper was virtually devoid of any sizeable population until its official founding at a public meeting on May 30, 1864. What can be ascertained is that miner Joseph R. Walker and others established a mining camp along Granite Creek in Yavapai County that would soon be known as Prescott. About a year later, the first of Prescott's "families" arrived, too. Certainly, some women were included in those first groups of migrants, but the vast majority of Prescott's newcomers were men. The major influx of miners continued as gold was discovered along Lynx Creek and other places. This migration continued well into the 1860s and beyond.

The first territorial census, as it applied to Yavapai County, was conducted between February and April 1, 1864. Since the city of Prescott would not officially exist until May 30, there is no way of knowing whether any of the seventeen "mistresses" identified in the census lived near the fledgling city. It is certainly possible, given that at the time there was really no place else for them to live other than in the few primitive mining camps scattered around town and in the nearby Bradshaw Mountains.

Prescott proper began first selling lots in June 1864. The first plat map allowed for a central courthouse plaza bordered by Gurley, Cortez, Goodwin and Montezuma Streets. Numerous businesses, from stores to saloons, soon sprang up on Montezuma directly across from the courthouse plaza. Here, the discerning newcomer to town could find myriad activity. The street fairly teemed with life day and night. Races on horseback and on foot took

Wild Women of Prescott, Arizona

Newcomers to the western frontier could relieve the stress in their lives by patronizing primitive saloons. *Jan MacKell Collins.*

place as excited gamblers bet on their favorites. The winners could spend their money in one of a dozen or more saloons. Those taverns with two stories could accommodate working girls upstairs. Ladies of the evening also established their own quarters in and around the plaza.

In those early years, city founders and their growing male population could hardly be concerned with the handful of working girls in their midst. In fact, prostitutes do not appear in any other public record until April 1868, when the *Arizona Miner* newspaper reported on shots fired at a brothel on Montezuma Street. The newspaper did not react well to this sudden outburst by a class of people who were supposed to remain out of the spotlight and conduct business quietly.

In reaction to the shooting, in which nobody was harmed, the paper made its opinion on the matter clear. "The shooting was done by a courtesan who lives in the den...who occasionally becomes highly elevated, and makes night hideous with bacchanalian revels," the article read. "If better order is not maintained in the sinful den, it would not surprise us to see the concern cleaned out before many weeks. It is a dangerous nuisance, and should be abated."[2]

As was common among western prostitutes, the ladies refused to go and instead began slowly increasing in number. By 1870, at least five prostitutes were operating in Prescott. The bad girls blended in rather easily with their more respectable neighbors, who included miners, merchants, farmers and

families with children. In November, however, an editorial in Prescott's *Weekly Arizona Miner* expressed further disgust at the presence of prostitution in town. "There is not, in all Arizona, a more dangerous or demoralizing institution than the frame house on Gurley Street," declared the paper, "in which a party of abandoned women hold forth, day and night, dancing, yelling, and capering about with masculines [*sic*] as abandoned as themselves. The vile place is upon a public thoroughfare...right where decent, respectable ladies and gentlemen have frequently to pass. We submit that it ought to be closed."[3]

Prostitutes who felt intimidated by such statements were free to ply their trade elsewhere. The nearby and blossoming Bradshaw Mountains, which fairly teemed with both obscure mining camps and growing settlements, offered accommodations where a gal could make some money without authorities poking their noses into her business. Sex was for sale in the mining and railroad towns of Octave, Tip Top and several other locales that already had saloons and gaming places. Within a decade, such satellite towns as Ash Fork, Jerome, Wickenburg, Kirkland and Williams also would sport one or more houses of prostitution.

Until about 1879, there is little to suggest that Prescott's working girls had moved down to Granite Street, the eventual center of the city's demimonde.

The Connor Hotel in Jerome was one of many places where the town's red-light ladies hung out. *Jan MacKell Collins.*

Wild Women of Prescott, Arizona

The only known questionable business there in 1871 was a dance hall. There, according to the *Miner* newspaper on February 25, a Mexican man who had killed a soldier at a dance house on Granite Street feared for his life. Early on, however, Granite Street bore little mention in the local papers. Property owners of the western half of Block 13—the famed "Whiskey Row" being on the eastern half—initially consisted of early prominent businessmen of the town. Property owners along South Granite Street in Block 13 during 1864 included William Hardy, who would later make a name for himself by establishing the Hardyville-Prescott Road, the former of which was eventually absorbed by Bullhead City. Henry Fluery, who was serving as Governor John Goodwin's personal secretary during 1863–64, also purchased property.

The real estate on South Granite in Block 13 changed owners in 1867, when Hardy sold two of his lots to Andrew Moeller. Interestingly, Moeller had served in the territorial legislature and had practiced medicine prior to arriving in Prescott as a miner in 1864. Although there is no evidence that Moeller operated a brothel on his Granite Street property, he did open the Diana, a bar and billiard saloon at the corner of Montezuma and Gurley Streets. The Diana included a brothel during the 1870s and beyond.

Subsequent property owners on South Granite Street included Henry Peeples of Peeples Valley in 1870, probate judge Hezekieh Brooks in 1872 and surveyor general turned leading merchant Levi Bashford in 1874. Other owners were James Sanford in 1875, grocer Nathan Ellis in 1878 and E.W. McNutt. In February 1879, McNutt sold Lot 7, Block 13, to "Hamilton, Fitch and others." Because madam Mary Annie "Ann" Hamilton later owned Lot 7, it can be presumed she was brought on as an initial partner in what would become Prescott's official "restricted district." Entertainment on Granite Street included not only fledgling bordellos but also saloons and at least one gambling house. Poker was carried on there, too, as evidenced by a number of poker chips and gaming pieces unearthed in 2004. The girls on the row knew that offering libations and gambling could eventually lead to sex, for which they generally charged about one dollar.

By 1879 or 1880, most of the prostitutes along Montezuma Street had relocated to Granite Street. Author, historian and poet Gail Gardner described Prescott's view of these women and their section of town:

> *To the nice people it was known as the "restricted district." The term was a misnomer for in no section was action less restricted and joy less refined. The man in the streets called it by a short, much more accurate and much*

Early on, Fort Whipple relocated from today's Chino Valley to Prescott, where ladies of the lamplight could service soldiers. *Jan MacKell Collins.*

more descriptive name. The nationality of the occupants of these rows of little ten by twelve rooms was varied, but all were practicing the oldest profession. The wares were displayed behind screen doors in good weather and behind lighted windows in bad.[4]

Women of the town were also free to service soldiers from nearby Fort Whipple. In the Bradshaw Mountains, several mining camps boasted of saloons and a few shady ladies. At the Peck Mine in 1880 were three women: Jaim Lam, a thirty-year-old Chinese woman; Josepa Noreiga, born 1855 in Mexico; and Maria Quinn, also born in Mexico in 1856. More women were located at the mining town of Tip Top.

Prostitutes at Tip Top in 1880
Carsdale, Alice, born 1858 in South Carolina
Delinque, born 1852 in China
Griffin, Francisca, born 1845 in Mexico, head of household
Mansfield, S., born 1861 in New York, head of household
Morales, Mary, born 1851 in California, head of household
Smith, Nellie, born 1846 in New York, head of household
St. Clair, Mabel, born 1861 in California, head of household[5]

Back in Prescott, property owners along Granite Street in Block 13 remained stagnant for several years. Ann Hamilton took over sole ownership of Lot 7 in August 1881. For the next several years, she remained the only female property owner on Granite. Her male counterparts still included Andrew Moeller and Nathan Ellis, but property owners beginning in 1882 included even more prominent men. Some of them were blacksmith Fred G. Brecht, Sheriff Joseph R. Walker and John Sorg, who with his family lived just a stone's throw away from Granite Street prostitutes Francisca Tranery and Elizabeth Arbuckle. Also listed among Block 13 property owners in 1882 was Quon Clong Gin, who constituted the only Chinese person to have property across Granite Street from Prescott's small but busy Chinatown.

Prescott incorporated into a city in 1883. The authorities immediately established a host of ordinances against visiting opium dens, cross-dressing or using obscene language—but not prostitution. There was no sense in outlawing prostitution anyway, seeing as so many important men seemed to reign over the red-light district. When Andrew Moeller died in January 1885, his property on Granite passed through lawyer J.J. Hawkins and Charles Cohen of the Prescott Land and Improvement Company before eventually being turned over to Moeller's widow, Alice, in 1888.

Alice Moeller still owned her property next to Ann Hamilton's former bordello in February 1889, when the house was sold to Morris Goldwater. The son of an immigrant from Poland, Goldwater came to Prescott in 1876. His father and uncle were merchants prior to coming to Prescott, and their

Wild Women of Prescott, Arizona

The coming of the railroad to Prescott beginning in 1886 helped increase the population of the growing town. *Jan MacKell Collins.*

department store there catered to the needs of the city's growing population. Morris became so popular that he was elected mayor in 1879. His nephew, Barry, later became a state senator.

The Goldwaters were well known in Prescott for their department store. The first enterprise of Morris's father, Michel, and uncle Joe, upon their arrival in America during the 1850s, had been to open a first-floor saloon under a second-floor brothel in California. Later, too, Morris would be admonished by city authorities after it was discovered that he continued living with Mrs. Sarah Fisher after her husband died (Morris did marry her, in 1906). These, as well as nephew Barry's fond recollections of Whiskey Row and its inhabitants in later years, support the idea that Morris Goldwater and his family approved of the red-light district on Granite Street, so much so that Morris readily became an investor there.

Like Morris Goldwater, the City of Prescott continued with its lackadaisical attitude toward the world's oldest profession. And the law certainly seemed to look the other way in 1889, when Prescott's seat as the capital of Arizona Territory was successfully challenged again. This time, the challenger was the growing city of Phoenix.

Barry Goldwater later told a story about the "leader of the senate" who, on the night before the voting session, visited his favorite courtesan above

Wild Women of Prescott, Arizona

The Palace Saloon, pictured here in about 1900, quickly became known for the soiled doves who worked there. *Jan MacKell Collins*.

Patrons at the Palace Saloon could access their choice of ladies of the evening via stairs leading to the second floor. *Jan MacKell Collins*.

the Palace Saloon on Montezuma Street. The story revolves around the man's glass eye, which some Phoenix officials paid the woman to steal. The clandestine crime was completed in the dead of night. The next morning, the man was too embarrassed to show up to vote without his eye, costing Prescott its precious capital one final time.[6]

Prostitution also took place on the upper floors of other taverns along Montezuma Street. The ladies of the evening could easily have worked in such places, in shifts, while living elsewhere. This would explain why so few prostitutes are documented amid claims that their numbers were many in 1890s Prescott. Early on, however, the red-light district on South Granite Street had its own two-story tavern. This was the Union Saloon on the southwest corner of Granite and Goodwin Streets, which functioned as the center of the demimonde.

The Union occupied two lots on Granite. To the south—and also to the east on Goodwin Street, all on the same property—were a number "cribs." These one-room, row house bungalows typically had parlors in the front and bedrooms in the back. In Prescott's case, the cribs shared a common roof. A "boardinghouse" also was located at the back of the lot on the alley. The buildings on Granite, Goodwin and the alley shared a common back lot, accessed from the Union Saloon but also from the cribs and brothels, as well as the alley dividing the red-light district from Whiskey Row. Other smaller cribs occupied the back of the yard and the southern border of the property.

The Union Saloon at the corner of Granite and Goodwin Streets was the heart of the red-light district for many years. *Courtesy of the Gabriell Wiley estate.*

Prescott's earliest Sanborn Fire Insurance map discreetly identified the brothels at the corner of South Granite and Goodwin Streets as dwellings and boardinghouses.

 Heading north on Granite, next to the Union Saloon cribs, were four structures identified on the 1890 Sanborn Fire Insurance map as "Chinese." These included three buildings on the alley, facing the backs of the saloons along Montezuma Street. Gaming pieces, namely poker chips, were recovered from this property during an archaeological dig in 2004, as was opium paraphernalia. Next to the Chinese structure was a boardinghouse

The Union Saloon as it appeared in about 1890. *Sharlot Hall Museum, shmbub8069pc.*

that likely functioned as a brothel, and next to that was Ann Hamilton's former parlor house.

By 1895, the red-light district had been built up quite a bit. The Union Saloon compound now included two restaurants, more cribs and a well in the common area. The cribs along Goodwin Street also had been replaced with larger bordellos. Each featured a porch from which the ladies could solicit their customers. The Chinese place next to the Union on Granite now included a saloon and dance hall. The house between there and Ann Hamilton's former brothel had been expanded to look like a large hall, with a separate kitchen on the alley. Across the street, on the southwest corner of Granite and Goodwin, there was now a fairly large dwelling known to operate as a brothel. Other buildings in the vicinity suggest that more brothels had been built as well.[7]

That Prescott's prostitutes lived in crowded, dirty and unhealthy conditions is a given since the majority of the red-light district was crammed into the east side of Granite Street between Gurley and Goodwin Streets. A June 21, 1900 editorial pleaded for the "alley between Granite and Montezuma streets [to] be cleaned up as the stench arising there from is terrible."[8] The writer got his wish on July 14, when Prescott suffered a fire at the hands of a careless miner and his candlestick and both the red-light district and business district burned. The city's legendary history stories

claim that residents simply moved their goods, including the sizeable bar and back bar at the Palace Saloon, across the street to the courthouse plaza. There, business owners and customers resumed gambling and drinking as the flames burned down the town. If this story is true, the town's wanton women almost certainly followed suit.

Curiously, the newspapers commented very little on how the fire affected the restricted district. One item of note appeared in Prescott's *Arizona Weekly Journal Miner* newspaper on August 1, 1900, regarding the sale of Varney Stephens's building at the corner of Gurley and South Granite. "The residence of Mr. and Mrs. V.A. Stephens on Granite Street has been sold to the proprietor of the Phoenix Saloon for $3,000 cash and the new owner has taken charge," the paper said. "Considering the locality and the condition of the building, this price is simply astounding."[9]

Like those on Whiskey Row, Prescott's prostitutes spent the days after the fire shoveling the burnt remains of their existence into the surviving basements and stairwells in their district and started over. The new houses of ill fame were simply constructed over a fresh layer of dirt brought in to cover the burned buildings and ashes. This time, the exuberant ladies rebuilt their establishments bigger and better than ever, even exceeding the original boundaries of the red-light district. "The *Courier* is told that there are now over one hundred female denizens of Prescott's tenderloin district," tattled one newspaper. "The district is certainly spreading beyond its old time bounds."[10]

The burned restricted district is visible behind the arches of the Palace Saloon following the 1900 fire. *Jan MacKell Collins.*

The district was indeed expanding, but the property north of the Union Saloon complex, including the sites of the Chinese dance hall and Ann Hamilton's brothel, had been abandoned in favor of moving farther south on Granite Street. Within a year of the fire, according to the 1900 Sanborn maps, Prescott's red-light district had grown to take over much of Blocks 19 and 72 south of Goodwin Street, while Chinatown flourished directly across the street to the west. The Union Saloon cribs were now nice and tidy in appearance, with storage sheds and a shared water closet in the back lot. The scene across the street on the southeast corner of Granite and Goodwin was identical and even included an outdoor kitchen. Other new brothels were scattered halfway down the block. Across the street, on the west side of Goodwin, two brothels—one small, one large—flourished with a sizeable saloon located in between them. These were accordingly labeled as "female boarding."

The giddy girls of Granite were gayer than ever. As a child, Gail Gardner remembered seeing some of the fancier madams and their gambling consorts as they passed by in a carriage:

> *The gamblers wore dark suits, starched collars and derby hats. The ladies were like Easter eggs, painted and hard boiled. They had buttons and bows and furbelows. They had ostrich plume hats, and the little lace parasols. The driver wore a high silk hat and a black frock coat. A lap robe covered his Levi-Strauss overalls. Well, this equipage passed us, and we children stood up and said, "Oh, mother, see the pretty ladies." Mother said "Shhhh" and put her hands on our heads and pushed us down again, and right then and there was when we children learned that it was not good manners to point.*[11]

Gardner also said his mother's friends referred to South Granite Street only as "the restricted zone" and that he and his buddies were strictly forbidden from going near the area. The children, however, rode their ponies near the red-light district at every chance they got in order to watch the goings-on. Everybody knew that prostitutes lived and worked down along Granite Street. And while the occupants of other such places in Arizona were being constantly harassed, nobody cared to do much about it in Prescott.

The fact that Prescott's red-light district was expanding attests to the city's permissive attitude toward prostitution. The working girls enjoyed a freedom like in no other place in Arizona. They could come and go pretty much as they pleased, some even taking excursions or temporarily moving to mining and railroad towns in the Bradshaws. Stage roads, such as the one running through the town of Mayer some twenty miles south of Prescott,

The brothels at Mayer, constructed about 1900. *Jan MacKell Collins.*

also provided opportunities to work out of roadhouses. Some women may have worked out of Joe Mayer's Fashion Saloon at his namesake town, which advertised in 1898: "Whiskies, Brandies, Wines & Cigars That Can't Be Beat in Arizona. A Sociable Game of Cards Always on Tap."[12] Later, the bar was known as the Mayer Tavern and Dance Hall, and beginning in 1900, it featured a massive Brunswick bar that was purchased in Jerome. Although the saloon did feature games of chance that included craps, plenty of old-timers verified that the dance hall portion of the business was more of a community affair than a place where miners could purchase a dance from a lady.

But Joe Mayer also built two sets of crib-type structures across from his saloon. Each building contained three apartments. Each apartment consisted of two rooms, front and back doors and a shared outhouse in back. The buildings may have been originally intended for railroad guests or overflow when the hotels were full. There is every chance, however, that the buildings also served another purpose. Mayer resident Frank Polk later verified that the structures, now known as the Mayer Apartments, "weren't what you'd call 'good houses.' They were, well, you know, 'houses.'"[13] If soiled doves were not always present in Mayer, they at least passed through now and then. Once at the White House Hotel, located near downtown, a couple checked in as husband and wife. The two retired upstairs, where they shared

By 1901, Sanborn maps were identifying the brothels of the red-light district as "female boarding," a common euphemism for the time.

some libations. Sometime later, the inebriated gal proved highly entertaining to the resident miners of the hotel when she "skipped light-heartedly down the stairs and into the lobby" wearing nothing but her birthday suit.[14]

From Mayer, travelers from Phoenix could easily catch the train or take the stage road to Prescott. By 1905, the city was still embracing the red-light district, perhaps even extending sympathy when times were slow due to a decline in mining. When Alex Dambry, owner of the Union Saloon, died unexpectedly in September, the newspaper kindly described him as "a man of wide popularity, gained during his residence here."[15] Other businessmen began investing in red-light property, perhaps because it was cheap and also in an attempt to keep the girls in business. Property owners of note were Bob Brow and R.H Smith, the same fellows who owned the Palace Saloon on Whiskey Row. The gentlemen opened a stable in proximity to the girls on the row.

Efforts to revive the shrinking red-light district were a limited success. A lot of girls were simply retiring or moving on to greener pastures. Their decisions to leave Prescott were also due to growing social pressure from church organizations, as well as from territorial officials as Arizona leaned toward statehood. Some of those women who left were simply replaced by newcomers, and the 1910 census records about thirty soiled doves in town. Sanborn maps that same year also show that other businesses, including the Scopel Hotel on Montezuma, were expanding into the district. New cribs appeared on the map as the old places continued being labeled as "female boarding." The city continued welcoming such brazen entertainers as Grace "Little Egypt" Bartell, who first introduced her legendary belly dance at the World's Columbia Exposition in Chicago in 1893 and performed at the Palace Saloon in 1910. Meanwhile, Chinatown held its own directly across from the Granite Street cribs, between Gurley and Goodwin.

With Arizona entering statehood in 1912, authorities were forced to crack down on the red-light district. Still, it would be quite a few years before the girls of Granite Street would vanish once and for all.

Chapter 2
A Tough Life

The romantic notion that everyday life as a prostitute was somehow fun is misleading. In truth, only a handful of women in the industry were successful, wealthy, happy or able to marry and leave the profession. The rest, who number in the thousands across the West, led downright dangerous, depressing and thankless lives. And although Prescott was amazingly tolerant of the shady ladies in its midst for some seven decades, such women suffered their share of mishaps and troubles just like any other working girl.

The 2004 archaeological excavation of the red-light district in Block 13 was most telling in how its inhabitants lived. Of 348 bottles recovered, roughly 75 percent of them once contained alcohol or drugs. Another 11 percent consisted of perfume, mouthwash and hair dye. Numerous pieces of firearms and ammunition were also recovered, attesting to the rough life both residents and visitors must have led.

Although Prescott acted much more kindly toward the wayward girls than other places, local newspapers did occasionally make fun of them. In 1870, the *Arizona Miner* noted that "a day or two ago, two 'fast' females, of rather loose character, habited themselves like men, when each straddled a horse and rode through town with the ease and grace of a couple of newly arrived Chinamen. Considerable laughter was indulged at their expense."[16]

Not only prostitutes, but even respectable women were expected to keep their "place" with regards to societal norms. Annie Lount was a housewife who dared to publicly express her dissatisfaction with her husband's impotence during the 1870s. By doing so, Mrs. Lount was denounced by Prescott's respectable

Wild Women of Prescott, Arizona

society as a bad woman. "Mr. O.A. Noyes…said that you was the worst man in camp to run after the women of worser [sic] character," Mrs. Lount wrote to her husband, George, "and that I was a woman of bad character and he said I was of ill fame, anything but a decent lady."[17]

The experiences of the two "fast females" and Mrs. Lount were exceptions to Prescott's lenient attitudes about prostitution in their midst. More often, public records exhibited sympathy and courtesy toward Prescott's "wicked" women. Many of those prostitutes who succumbed to their lifestyles were respectfully buried in Citizens Cemetery, Prescott's early graveyard dedicated to pioneers from all walks of life. An exception to the rule, however, were the "Chinagirls," the most put-upon workers of the demimonde in Prescott.

When George G. Fish painted *The Sirens* in 1864, the mythological nymphs furthered the idea that cavorting with women was a bad idea. *Jan MacKell Collins.*

Like elsewhere in the West, the pioneers of Prescott did not think much of the Chinese immigrants who began coming to town early on. Even so, over time those Chinese who stayed quickly found that running restaurants and laundry services could be very lucrative. On March 11, 1871, the *Weekly Arizona Miner* expressed its thoughts on the matter: "Among the passengers [on the Wickenburg Stage] was a Chinese female, the first that has ever visited this town…and, we hope, the last."[18]

The anti-Chinese sentiment was alive and well in Prescott, but local opinion did little to keep immigrants out. By 1873, there was at least one Chinese house of prostitution in Prescott, evidenced by newspaper reports of several soldiers who smashed the windows and threatened the girls until

Early risqué postcards made light of infidelity, but in real life, the subject was taken quite seriously by society. *Jan MacKell Collins.*

a night watchman ordered them to stop. The vandals claimed they were seeking vengeance because they suspected a Chinese man of killing a fellow soldier. The accused was out on bail. The soldiers were never punished for their crime.

As immigrants from China continued appearing throughout the West, word eventually reached town that many of the women sailing into San Francisco Harbor were immediately being sold for sexual purposes. Although this cruel practice does not appear to have happened in Prescott, the local papers had something to say about the happenings in California and other places. "The importation of Chinese women for immoral purposes is a crying disgrace to the United States and to American civilization," a local writer proclaimed. "It is a so-called civilized government acting the part of procuress, but although the better sense of the country has long cried out against it, the infamous traffic still continues."[19] Even as sympathizers voiced their objections on behalf of Chinagirls, however, sentiments were running high against both male and female immigrants in 1879. An October newspaper item noted that "Prescott has about 75 or 80 Chinamen, which is 75 or 80 too many. Now is a good time to get rid of them."[20]

Prescott's Chinese population, however, refused to go away. As of the 1880 census, there were five working Chinagirls in Prescott. One other lived at the nearby mining town of Tip Top, and two more could be found at the Peck Mine. In Prescott, the known prostitutes were Sam Boy, Ah Chi, "Mary," Yu Ky and Chow Oi. Their statistics are interesting. All of the women listed themselves as married. Three of them lived on the demimonde side of South Granite Street across from "Chinatown," but Yu Ky and Mary shared a house near Sisters Hospital well north of the red-light district. Sam Boy resided with two men who appear unrelated and worked as laborers. Chow Oi resided with her husband, Ah Chung, who worked as a cook. Ah Chi also resided with her husband, Ah Yong, who was listed as a keeper of a "house of ill fame."

As Prescott's population grew, so did its number of Chinese inhabitants. Between 1890 and 1895, Chinatown grew to include structures at the southwest corner of Goodwin and South Granite Streets, as well as a few buildings on the east side of Granite and the back of Whiskey Row. One of these structures, Joss House, served as a Chinese temple. Chinatown suffered through the flooding of nearby Granite Creek in 1891, but during the 1900 fire, the residents thought to use the creek water and form a bucket brigade. By doing so, they saved their intimate neighborhood while the red-light district across the street burned. By 1900, 156 people of Chinese descent

were living in Chinatown but also on Goodwin, Montezuma and Gurley Streets, as well as on Aubrey Street several blocks from downtown.

If the Chinese were victims of Prescott's prejudice, the town's Anglo prostitutes often brought their sorrows on themselves. In February 1875, the local newspaper published a classic tongue-in-cheek review of a scuffle. A lengthy description of that incident reported:

> *Tommasita, the "forsook," shot at Julia Granee, the new love, and chawed one of her digits as she would the developed resources of a tomale [sic]. Julia carved her antagonist as you would a "spitted" fowl, while the bone of contention viewed this national pastime with complacency and inwardly resolved to devote the remainder of his days to the survivor. Constable Leonard arrived at this juncture and brought the festivities to an abrupt termination.*

Tommasita pressed charges, and Julia had to appear before the grand jury. The outcome of the trial was not reported, although it was noted that Julia was "the same who cut Pancha Burnett badly some time since."[21]

Sometimes prostitutes played the part of heroes to their more respectable counterparts. In July 1876, the *Miner* reported that an "inebriated housewife," tired of her abusive husband, had taken refuge with a "soiled dove." The angry husband came after her, and when she refused to go home with him, he claimed he "spanked her gently on the hip as he would an erring child." Witnesses, however, testified that the husband's actions were excessive and violent. An all-male jury not only acquitted the unhappy housewife of being intoxicated but also encouraged her to divorce the man and charged him with assault and battery.[22]

The *Arizona Miner* also commented on Elizabeth "Blanche" Pennypacker, "an inmate of the City Prison on several occasions." Blanche traveled around quite a bit; the paper explained that she "and a Mexican senorita named Martha, with their worldly effects, took departure this forenoon for the booming Tombstone. What an acquisition that will be."[23] Blanche apparently returned from Tombstone sometime prior to 1880, dying from the effects of whiskey at Tip Top in April of that year at the tender age of twenty-eight years.

Another hard case was Rosa Duran, who arrived in town in 1903. In November 1901, Rosa had been charged with larceny at Ash Fork. She was sentenced to three years in the territorial prison at Yuma beginning on November 15. Rosa's prison record tells much about her. She was raised

Wild Women of Prescott, Arizona

The law often had little say over what went on within the confines of bawdyhouses, where alcohol and drugs could often lead to trouble. Jan MacKell Collins.

Catholic but could not read or write. She was single, listing her nearest relative as Juliano Almendez in Williams. Her stature was small at four feet, eleven inches, and 116 pounds, and she wore only a size three and a half shoe. Her hair color was undoubtedly brown, and she had black eyes and "bad" teeth. Surprisingly, Rosa smoked but was otherwise "temperate."[24] During her imprisonment at Yuma, Rosa spent three days in the "dark cell" for fighting. Lucky for her, overcrowding resulted in her parole on December 15, 1902.

 Upon her release, Rosa decided to make a fresh start in Prescott, arriving in about March 1903. For the next year, she was on parole, her time officially expiring on March 14, 1904. Over the next four years, Rosa managed to stay somewhat out of the arms of the law. But in 1908, she and Ella Wilton, aka the "Turkey Herder," were arrested for robbing Yee Jackson of forty dollars. Deputy Sheriff Meritt was only able to recover six dollars of the money, and both women went to jail. The paper was not as whimsical about this incident as usual. "The Chink, proprietor of a noodle joint, held Rose until the arrival of the officers. The 'Turkey Herder' was gathered in later by Night Officer

Wild Women of Prescott, Arizona

Rosa Duran's mug shot from Yuma Territorial Prison, taken in 1901. *Courtesy Yuma Territorial State Prison Park.*

McMahon." As of May, both women remained in jail pending a hearing before the grand jury.[25] Nothing more was heard of Rosa until her death on Granite Street on February 11, 1915. The cause of death was pneumonia. Rosa's parents, Reyes Rio and Juliann Hernandez, were notified, and Rosa was respectfully buried in Citizens Cemetery.

The antics among Prescott's redlight ladies continued. In May 1907, papers reported the robbing of the "French" house on South Granite Street by Ignacio Ramirez. In February 1908, Wallace Moore, "who chose the middle of Granite Street as a quiet place in where to sleep off a jag," was sent to jail when he could not pay a ten-dollar fine for the crime. Just a week or so later, a black man named William Jones, better known as "Jockey Bill," shot Ed Connors in the right thigh in the red-light district.

Things did not get much better as the year progressed. In April, Faustina Cruz and Alfonso Moreno "shot and carved, respectively," one Angle Perez in a Granite Street saloon.[26] Just one month later, on May 10, Faustina gave birth to a stillborn baby at her home at 219 North Granite Street. Such antics were not unusual. The December 1912 issue of the *Weekly Journal-Miner* reported on prostitute Mattie Estes, who unaccountably "slashed" another young woman, Elodio Maxwell, in the side. Elodio's wounds were considered serious, though not bad enough to merit taking her to the hospital. Mattie, whom witnesses testified was on "a drug to which she is said to be addicted," was taken to jail.[27]

Even prostitutes who defended themselves against their abusers sometimes wound up in court. In 1913, May Clark, who had bounced

Images such as this one of an unidentified young lady did little to dispel the notion that prostitutes were willing to flaunt their wares in public. *Library of Congress.*

between Prescott and Seligman for some time, was arrested for the shooting death of Charles Pitts in the latter town. According to May and others, she and Pitts "had been particular friends" the previous spring, until they had a "falling out" in April. Later, it would also be revealed that May had a certain "medical condition" that required treatment in Prescott. (May's "condition" may have been a pregnancy. Newspapers of the time often avoided pointing such things out.) Evidence later showed that she sent several letters and

telegrams to Pitts between May and September, during which time he sent her twenty-five dollars while she was in Prescott.[28]

Upon her return to Seligman in September, May had told Pitts to keep away from her. But on September 9, the day of the shooting, Pitts approached May and "suddenly hurled himself upon her and seized her throat with both hands. Finally managing to break his grip, she reached under her pillow, secured the gun, placed it to his stomach and pulled the trigger." It was initially believed May had a gun on her person, but she later testified that the weapon was under her pillow.[29]

Pitts was put on a train to Los Angeles to receive emergency medical attention but died on the way. May, meanwhile, turned herself in to authorities. A preliminary hearing in Ash Fork did little to satisfy county attorney P.W. O'Sullivan, who vowed "to get to the real facts of the case." What most likely bothered him is that, after bonding out in Ash Fork, May had left for Prescott. May's attorney, R.P. Talbot, was instructed to make sure May stayed in town.[30]

At her trial in December, May, "attired in a costume of deep purple velvet" and her hat "a singularly rich creation," walked into a courtroom full of onlookers and eagerly watched the proceedings. "Possibly never before has anyone accused of murder in the local court displayed such marked concern," commented the newspaper.[31] May was perhaps more interested in the proceedings than the trial, for only two witnesses were called. The first witness was Maria Harvey, a fellow prostitute who roomed next door to May in Seligman.

Maria said that on the day of the shooting, a drunken Pitts had knocked at her door and that she had told him to go away. Moments later, she heard a "muffled" shot and opened her door to find Pitts lying on his back and moaning. Maria closed the door in fright, and when she opened it again, two men were bending over the prone man. The second witness was Jack McCay, who said that he had just been chatting with May behind Frank Dickerson's saloon and that as he reentered the bar, he heard a shot.

The trial ended with May's acquittal, and the newspaper noted that May "laughed and jollied with several of her friends." County officials were unsatisfied with the verdict, however, and promptly arrested her again.[32] At her second trial later that month, the witnesses again testified, along with five others. Four of them were men who testified that Pitts was drunk and threatened May. The other was Francisco Ortiz, the only person who actually saw the shooting. The *Weekly Journal-Miner*, the only newspaper to cover the story, neglected to report what Ortiz said; nor did a follow-up

Wild Women of Prescott, Arizona

The fun-loving town of Seligman still celebrates its Route 66 status, as well as the shady ladies who once lived there. *Jan MacKell Collins*.

article reveal the outcome of the trial. It can only be assumed that May was once again acquitted and immediately disappeared from record.

If the law failed to quell the riotous spirits of the Granite Street ladies, death often did. The life of a working girl could indeed be deadly, whether her end came by illness, disease, drink, drug or—saddest of all—her own hand. Often, newspapers could shed little light on these women's pasts. When Corrine Dumas, a musician at the Union Saloon, died of pneumonia in March 1902, all that was known about her was that she was from Arkansas and about thirty years old.

And there were more: In 1910, Hacoba Sandida of 217 South Granite died of "anasarca," a form of edema caused by liver failure. A year later, Louisa Cruz died at 220 South Granite from "cancer of the stomach and general dropsy." Both women were buried at Citizens Cemetery. Other girls who merited burial in the cemetery included thirty-four-year-old Clara Layton, who died at the County Hospital from "abscess of liver" in July 1911, and Cora Knowles, who died of alcoholism at her home on South Granite in 1912.[33]

If alcohol, drugs or poison didn't do the girls in, they did frequently choose to end their own lives. Witness Florence Hicklin, "a woman with a history," who killed herself at Blanchard, located near the Iron King Mine south of Prescott, after a fight with her man. In this instance, Florence shot herself in the head at the Grand View Saloon on July 3, 1906. Marked as a "Saloon

The cemetery at Humboldt includes many unmarked graves, including those of working girls who were interred there at the expense of kindly locals. *Jan MacKell Collins.*

Woman," all that was known of Florence is that she was born in Chloride, New Mexico, in August 1886. Her troubles, aside from the quarrel with her lover, included the arrest, along with her brother Fred, for the murder of one Jud Molino back in 1904. Florence's body was brought to Prescott and buried at Citizens Cemetery.[34]

Just a few months after the untimely demise of Florence Hicklin, another woman known only as Edna killed herself at her home in the town of Humboldt, not far from Blanchard. The newspaper identified Edna as "a colored woman, formerly a denizen of the red-light district of [Prescott]." Edna was apparently upset "because her lover deserted her for another charmer" and purposely overdosed on morphine. The paper noted that Edna would be buried in the Humboldt Cemetery, "at the expense of the county."[35]

There is much evidence to suggest that, as much as the working girls of Prescott met untimely deaths, at least some local citizens expressed sympathy toward them. During the 1880 census, twenty-year-old Mary Dunphy was found at the home of Constable Frank Murray and his wife. Although Mary

was identified in the census as a prostitute and was no doubt serving time, she is listed as a "visitor" in the Murray home. The census states that Mary was born in California and that her parents were both born in Boston. No other information about her, including what became of her, has been found.

Surprisingly, nobody has come forth with a legendary tale comprising more fiction than truth regarding Mary Dunphy. But plenty have given testimony to "Flossy," a girl from South Granite with whom convicted train robber turned murderer James Fleming Parker requested a visit before he was hanged. The story about Parker is well known—an orphan by age fourteen who began his criminal career serving time at California's San Quentin Prison in 1885 and again in 1891. In between jail times, Parker worked as a cowboy in northern Arizona. He was also said to have visited Prescott in 1888.

In February 1897, Parker decided to try something more lucrative by robbing the train outside Peach Springs between Seligman and Kingman. The robbery was botched when Parker's partner in crime was killed at the scene, and the would-be robber lost the loot while escaping the posse. After running from the law for about a week, Parker was finally captured near the Grand Canyon and sentenced to jail in Prescott. A few months later, he escaped, this time murdering assistant district attorney E. Lee Norris in the process. Justice was swift, and Parker was sentenced to be hanged in the courthouse square on June 3, 1898.

Over time, various stories have popped up stating that in lieu of his last meal, Parker requested a visit with the alleged "Flossy." That this colorful moniker has been assigned to many ladies of reputable question is known among prostitution fans everywhere. Also in question is just when Parker may have met this maiden, what with being busy robbing trains out of the area and getting locked up in jail for it. If Parker was indeed in Prescott in 1888, could he have met the mysterious Flossy then? Not likely, as very few of Prescott's prostitutes hung around town for very long before moving on to greener pastures. But if the tale of Parker spending "an hour together" with Flossy before meeting his maker is a tall one, it does deserve mention as one of the many ways the town harlots endeared themselves to historians in Prescott and beyond. In other words, if it isn't true, it ought to be.

More stock can be put into the real story of Blanche Hardwick, a twenty-three-year-old opium addict who cried for help from the people of Prescott—and got it. The March 14, 1914 issue of the *Weekly Journal-Miner* led off with the headline, "Girl More to Be Pitied Than Censured." The article focused on Blanche, who had left her parents' home in Texas some six years before.

The paper explained, "The girl was brought up among environments in sad contrast to her present day life." Time away from her home, combined with illness and depression, led her to try opium.[36]

Unable to break her habit, Blanche ultimately moved in with sixty-year-old George Roberts, who was married and a "negro" besides. Roberts "agreed to furnish either the dope or the money to purchase it with." When the unlikely couple was arrested and brought into court, Blanche broke down and sobbed. "Oh, I'm tired of this life I want to get away from it," she said. "I want to go back to the kind of people among whom I was raised and of whom I am one. It's true I have made my mistake but isn't there some remedy?"[37]

The county physician, H.T. Southworth, examined the needle marks on Blanche's arms and asked several questions, which she readily answered. Her cooperation and desperate pleas were truly convincing. "The officials have taken a kindly interest in the case," the paper concluded, "and the girl will be removed to the county hospital where an effort will be made to cure her of the drug habit."[38]

In the weeks following, George Roberts pleaded guilty to "notorious cohabitation and adultery" and was given the "maximum" sentence. Meanwhile, Blanche singled out Carrie Neil (aka Neal), "an old negress of Granite Street," who sold the dope to her and three other people. Blanche would "attribute to the negress her downfall in a great measure." Carrie Neil was convicted and paid a fine.[39] Whether Blanche was able to reform remains unknown, but at the very least, Prescott citizens did their best to save one of their wayward girls.

Chapter 3
MURDER IN THE RED-LIGHT DISTRICT

Prostitution was a dangerous job. Women in the profession were subjected daily to such perils as violence toward themselves or those around them, drug and alcohol abuse, depression, illness or pregnancy and myriad other frightening dilemmas presented within their surroundings. Throughout the West, there is no shortage of ladies of the evening who were seriously injured, taken ill or died in less than normal circumstances. Even in a prostitution-tolerant town like Prescott, the chances of women from the row coming to harm were unfortunately likely.

The first murders of Prescott prostitutes on record took place in 1870, when both Jenny Schultz (aka Fanny Schultz, Jennie Gregory and Mary Anschutz) and Nellie "Ellen" Stackhouse were killed. When Jenny was shot at her bordello, located at Cortez and Gurley Streets, local citizens were both shocked and alarmed. "Dastardly Outrage," read the headline in the September 17 issue of the *Prescott Miner* newspaper. The article began in wholehearted defense of Jenny Shultz, "a lady of easy virtue" who "for some months past has lived alone in a house on Cortez, near the corner of Gurley Street, where her life has been quiet and her house orderly and peaceable."[40]

On the night of the woman's murder, Postmaster G.W. Barnard was readying for bed when he heard screams and "cries of murder" coming from Jenny's home. Barnard ran over to Jenny's and through the open door saw her on the floor. One of her customers, William Girtrude (also spelled Gertrude), sat on the bed with a pistol in his hand. Barnard ordered the man

With the plethora of alcohol, rough men and shady ladies available in Prescott during the 1870s, violent incidents were bound to happen. *Jan MacKell Collins.*

to leave. Girtrude stepped to the door but then turned and demanded ten dollars from Jenny.[41]

After some minutes of arguing with the woman and Barnard, Girtrude fired his pistol through the open door. The bullet struck Jenny. Girtrude next fled into the courthouse plaza across the street as Barnard ran for help. Upon finding Sheriff Taylor, Barnard located Girtrude near the Pacific Brewery, talking to two other men. Sheriff Taylor and a Mr. Gleason took Girtrude to jail, while Drs. Kenall and McCandless were summoned to Jenny's home.

Girtrude's bullet had shot the "defenseless woman" in the upper thigh and "striking the thigh bone shattered it fearfully."[42] Almost immediately, little hope was given for her recovery. On the twenty-fourth, it was reported that Jenny had succumbed to her wound. Subsequent articles about the incident claimed Girtrude was nearly lynched. "We were absent from Prescott at the time but have since learned that the feeling among the town was at a high pitch," the *Weekly Arizona Miner* reported, "and but for the District Court was about to meet, a swift justice would have been meted out to the murderer." Even *Miner* publisher John H. Marion later admitted he had been in favor of lynching Girtrude.[43]

William Girtrude had a hard time of it in jail. In February 1871, his mother sent him a letter, which he authorized a friend to retrieve from the post office. Instead, the messenger picked up the letter, "appropriated the contents to his own use, and left the country, thus proving himself a heartless scoundrel, indeed."[44] A final trial took place in October, over a year after the crime was committed. Barnard being the only witness, and Girtrude having no defense, the murderer was found guilty.

The presiding judge at the trial was detailed in pronouncing Girtrude's sentence to hang.

> *There are no extenuating circumstances in your case—not one single fact to plead in your favor. In the silence of the night, at about the hour of midnight, you entered the house of the deceased and demanded of her the paltry sum of ten dollars that you alleged she owed you...You were sitting on the bed, with a revolving pistol in your hand, and the deceased woman in a reclining position on the floor, where you had evidently thrown her...you deliberately shot the*

History likes to depict prostitution as a genteel affair, but women in the profession were often subject to violence. *Jan MacKell Collins.*

deceased, inflicting a wound of which she died in less than a week…Your stay on this earth is a short one; make the most of it and do whatever you may to "set your house in order."

Girtrude was then sentenced to hang on December 29.[45]

Jenny Schultz was barely in the grave when Nellie "Ellen" Stackhouse (née Ellen L. Crane) was murdered just two months later. According to the 1870 census, Nellie was twenty-three years old and born in Pennsylvania. Locals believed she came from Philadelphia but had a husband and child in San Francisco. The crime occurred on October 31 at Nellie's house on Montezuma Street, just a few doors down from the *Miner*, Prescott's leading newspaper. "Many of our people had almost forgotten that such a horrid crime [referencing the death of Jenny Schultz] had been committed almost in the heart of Prescott," the *Prescott Weekly Arizona Miner* began, when reports came of Nellie's murder. It was "a female friend of Mrs. Stackhouse, who called at her house about the middle of the afternoon, and who, upon failing to get a response to her knocks and calls for admittance at the front door, went around to the back door, which she found open, and entering, found her cold in death."[46]

Nellie's friend "immediately gave alarm," causing men to rush in from "every quarter of town." By the time reporters from the *Miner* got to the house, the crowd was already so thick "that it was with difficulty we got near enough to get a glimpse of the murdered woman, as she rested upon her bed, apparently asleep. But, it was the 'sleep that knows no waking.'"[47] Those closest to the body immediately noted the marks of fingers on her neck and blood running from the left side of her nose.

The newspaper also noted that Nellie's fingers "had been despoiled of rings" and her trunks were ransacked. Nellie Stackhouse, the paper concluded, had been murdered and robbed by one, "perhaps two," unknown persons. A juried inquest was quickly formed, but there being no hard evidence of who had been at Nellie's, the group was forced to render the verdict "that the deceased, Ellen L. Stackhouse…came to her death by strangulation and suffocation, by some person or persons unknown to the jury."[48]

As with Jenny Schultz, the newspaper created a public outcry on Ms. Stackhouse's behalf, calling her a "defenseless female" and identifying her killer as a "devilish monster."[49] Police were able to come up with only one suspect, a "Polander," who had argued with Nellie over some money. According to the *Miner*, the man had given Nellie the money, which she denied receiving, resulting in an argument shortly before she was killed.

"But, after a rigid examination and close watch on the prisoner," the paper reported, "the feeling became general that he was innocent, and he was discharged from custody."[50]

So heated were emotions over Nellie's murder that territorial governor A.P.K. Safford offered a $500 reward for information leading to the arrest and conviction of her killer. At the time, Safford had relocated, along with the territorial capitol, to Tucson. His reward offer is certain proof that the murder of a woman, even a tainted woman, was important enough to inform the entire territory and seek the guilty party. Unfortunately, Nellie's killer was never found.

The murders of Jenny Schultz and Nellie Stackhouse have long stuck in the minds of historians. The women's deaths, however, were certainly not the last acts of violence to mark Prescott's seamy side of life. According to Prescott's *Arizona Journal Miner* on March 8, 1873, a soldier from Fort Whipple was shot in the red-light district. A witness "found some soldiers in front of a Chinese house of ill-fame, in the alley, back of Raible's brewery." The guilty party, however, was not someone from the red-light district but rather a cook from Fort Whipple.[51]

Granite Street and areas like this stairwell below the Palace Saloon on Whiskey Row provided dark places in which to conduct business, hide or commit acts of violence. *Jan MacKell Collins.*

Wild Women of Prescott, Arizona

Regular barroom brawls aside, the public had yet to see much of any true troublemakers among Prescott's prostitutes themselves, until they were introduced to the likes of Bertha Reed. The incorrigible Miss Reed, who favored bouncing between Prescott and Ash Fork, first appeared on record in 1893, when she was arrested for poisoning James Gabel with an overdose of morphine. She was jailed until it was ascertained whether Gabel would survive, which he did. Next, the December 27 issue of the *Arizona Weekly Journal-Miner* reported, "Bertha Reed, who succeeded some time since in lodging a bullet in her leg has just had an operation performed at the hospital in which the ball was extracted."[52]

What the paper did not say was that Bertha shot herself on purpose and that one Tim Casey had looked after her as she recovered. Casey also established a relationship with Bertha, although it was noted that the twosome quarreled frequently. In March 1894, Casey knocked on Bertha's door in Prescott. A gambler named William Martin answered the door in his nightshirt. No doubt, this upset Casey, for Martin later testified that the neglected boyfriend marched over to the bed, slapped Bertha across the face and pulled a gun. Both Martin and Bertha later tried to convince authorities that Casey shot first, but what is known for sure is that Martin successfully shot Casey twice in the head, killing him. Both Martin and Bertha were arrested.

More information about Bertha unfolded, including the fact that she allegedly already had another lover who was currently serving time for a shooting affray at Ash Fork. Casey, meanwhile, was described as having "a good reputation as being a quiet and peaceable man." It was further noted that "he was intending to leave in a few days to visit his children at Santa Rosa, whom he has not seen in three or four years."[53] A few days after her arrest, Bertha was released from custody as Martin was scheduled for trial, but the outcome remains unknown. Bertha laid low until May 1894, when she was again arrested for loitering in Ash Fork's saloons.

The last anyone heard of Bertha Reed was in Globe, where she once again made her presence known several years later. In June 1907, a fellow prostitute, Ophelia Sanders, had Bertha arrested "for defaming her character."[54] Both women, who worked in the same brothel, were scheduled for court. The following August, when prostitute Alena Jasper threw a lighted lamp at Bertie Lee and Bertie died from her burns, Bertha was among the lengthy list of witnesses called to testify.

In December, Bertha was arrested in Globe yet again. This time, her crime was living with William Green, the "colored" proprietor of the Mandolin

Wild Women of Prescott, Arizona

A former brothel in Ash Fork of the type Bertha Reed worked in when she lived there. *Jan MacKell Collins.*

Club in Globe. The couple pleaded not guilty but was fined anyway. It was true love for Bertha, however. She and her man eloped to Juarez, where they were married, and then returned to Globe. All was well until Green, labeled a "black bully and bad man," was killed by John W. Sanford over a game of cards.[55] Sanford was declared not guilty in December, and Bertha Reed was heard from no more.

Back in Prescott, another prostitute murder was carried out on February 19, 1911, when Georgia "Georgie" Brown was shot by her lover. The killer was identified as a Fort Whipple soldier named Alexander Oaks. The couple had only recently arrived from California, and officers from the fort clearly remembered Georgie from her attire: a man's black derby with a blue veil, oversized shoes and short hair. Upon first sight of her, the officers said, they wondered whether she was a man.

Further investigations revealed a bit more about Georgie's background. Authorities in California verified that she had arrived in San Luis Obispo the previous January from San Francisco and Seattle. In Prescott, Georgie and Oaks had bounced around a bit, staying first at the Pioneer House, then at Tinsler Flats (where they were evicted), then at Lida Winchell's place on Granite and finally in Room 11 above the Star Saloon.

Not much remains of the red-light district in Globe, which once flourished along Pinal Creek. *Jan MacKell Collins.*

On the evening of her death, Georgie had just returned from dinner with another Fort Whipple soldier, Fred Kimbro. Minutes later, Oaks knocked on the door. Georgie let him in, and according to Kimbro, Oaks whispered something in Georgie's ear to which she replied. In a flash, Oaks drew a gun and started shooting.

Three shots hit Georgie, killing her instantly. A fourth shot hit the wall. "I don't blame you," Oaks said to Kimbro but fired anyway, shooting the man in the arm he had raised to defend himself. Oaks saved the last bullet for himself, shooting himself in the head and falling unconscious. He came to during the trip to the hospital, telling others, "She threatened to quit me for the soldier and I shot her." As an afterthought, he added, "I grew very jealous after she said she would leave me, but I don't know why I shot her."[56]

It was guessed that Georgie was about thirty years old, and "Don't know" was written in several places on her death certificate, including in the spaces for her birth date, where she was born and the names of her parents. Initially, Oaks admitted that he knew Georgie had a nine-year-old daughter who was living with the woman's friend but refused to give an address. In the coming

Wild Women of Prescott, Arizona

Women like Georgie Brown, as well as this unidentified woman posing in a photographer's studio, aspired to have beautiful looks and surroundings. *Courtesy Jay Moynahan.*

weeks, Oaks would tell no more about what he knew regarding Georgie's past, including where she came from.

Doctors operated on Kimbro's arm and predicted he would recover, although he would likely be discharged by the army with a permanent disability. By some miracle, it also was initially believed that Oaks might live in spite of his severe head wound. At the very least, authorities hoped he would be well enough to stand trial for the murder, since within a short time of the shooting he was able to walk and talk. By April, however, his condition had worsened despite two surgeries. He was last known as being in serious condition, with no other reports on his recovery.

Random shootings continued to occur on Granite Street, including the killing of James G. Thomas by George Besh at the corner of Gurley and Granite Streets in May 1912. Such violent incidents gradually reduced in number as the city, state and military forces began working to close down red-light districts across the country for good.

Even after military authorities methodically shut down red-light districts across Arizona in 1918, at least a few women clandestinely continued operations. One of them was Nellie Stewart, aka Nellie Campbell, who ran

WILD WOMEN OF PRESCOTT, ARIZONA

Unidentified barkeeps at a Prescott tavern. *Courtesy Gabriell Wiley estate.*

a "resort" on South Granite Street. On December 29, Nellie appeared at police headquarters with a most disturbing story. Four days earlier, she said, three soldiers from Fort Whipple had beaten another man to death at her place and hidden the body in a shed at her house.

Officers lost no time in going to Nellie's house, where they found her claim to be true. In a woodshed at the back of the house lay the frozen body of Manuel Gonzales. Most of the victim's clothing had been torn from his body, and the splinter of a broom handle had pierced one cheek and nearly come out of one eye. He had also been stabbed and otherwise beaten. Bloody clothing, discarded by his killers, was found in Nellie's house.

According to Nellie, Gonzales's troubles began when she was entertaining him, along with the three soldiers, at her house. All four of the men were drunk. One of the men, Juan Apodaca, had fallen asleep when Gonzales tried to rob him of his pocketbook, which contained around $100. Nellie witnessed the robbery, and her lecturing of Gonzales to put it back woke the sleeping soldier.

Apodaca called to his friends Monica Baca and Felix Griego, and the three men began beating Gonzales. The beating continued even after the pocketbook was recovered. Gonzales tried to escape out the back door as his assailants accosted him with a lamp, a slop jar, a two-by-four and a broom. The fight continued as far as the backyard until Gonzales fell. Then,

according to Nellie, the soldiers picked up the victim, threw him into her shed and headed downtown.

Nellie testified that she was afraid of arrest and so initially chose not to come forward. In fact, she said, she had wired the shed door shut to keep animals away from the body and fled to her mother's house on the west side of town. Ultimately, she had come to her senses and decided to notify the authorities about the incident. A search of the soldiers' quarters at Fort Whipple revealed more bloody clothing from the scene. The men, who claimed they were innocent, were booked into the county jail. As for Nellie Stewart, she was held under a $1,000 bond. When she could not raise the money, she was placed in the county jail as well.

After examining the accused men, authorities let Baca go. The others, along with Nellie, were held for trial in March 1919. Nellie proved a most uncooperative witness. Her reasons were not so much because she wished Apodaca and Griego to go free but more because she did not want to incriminate herself as a prostitute. When asked if she had recently been arrested for running a "disorderly house," Nellie verbally objected to the question until it was explained that she must answer. "There was an awkward pause," the newspaper noted, until "Nellie exploded. 'NO!'"[57]

The defendants were no more cooperative than Nellie. Each denied ever having seen Gonzales. They also claimed Nellie was drunk that day and capitalized on her inability to recall what time the incident occurred. It was also discovered that Nellie lied about not returning to the house, as a fourteen-year-

A 1908 postcard depicts a smoking dance hall girl, clearly a violation of societal norms. Jan MacKell Collins.

old girl had seen her and a friend carrying "some bundles" from the house within two days of the murder. Apodaca and Griego also claimed the fight was with their friend Baca, whom they later escorted back to Fort Whipple and assisted in cleaning up, hence the bloody clothing.

Over the next few days, more witnesses were called to confirm or dispute when and where everyone said they were. Additional weapons used in Gonzales's killing were brought forth. Then, on March 15, a retrial was requested. The judge said he would make a decision on March 17. In the end, Apodaca and Griego were sentenced to prison for a mere one to ten years. Nellie was set free.

The incident at Nellie's place was viewed as an indirect attack on the state and military efforts to rid Arizona of prostitution. "It is not too much to say that the existence of conditions which led to the killing of a Mexican bootlegger in a Granite Street resort…was a cause of diverting the war department's attention to Prescott," the local paper lectured. "It is the military method to cast out the now recognized denizens of places of ill fame, and any such places, no matter how or by whom operated, must go."[58]

Chapter 4
LADIES OF THE LINE

Although prostitution followed Prescott into fruition soon after its founding, documentation of the city's first shady ladies is scant. Only limited guesswork can be gleaned about the women who were identified as "mistresses" in the first census of 1864. Some of them may have been living close to Fort Whipple, originally established in Chino Valley some sixteen miles north, relocating to the banks of Granite Creek when Prescott was established. All that is known for sure is that the women lived in the Third District, which covered northern Arizona and today's Yavapai County.

MISTRESSES OF YAVAPAI COUNTY IN 1864
Pancha Acuna, 25, single, born in Mexico
Mariana Complida, 24, single, born in Mexico
Theodora Dias, 20, single, born in Mexico
Nocolasa Frank, 23, single, born in Mexico
Andrea Galinda, 24, married, born in New Mexico
Rosa Garcia, 25, single, born in Mexico
Perfecta Gustalo, 25, single, born in Tucson
Santa Lopez, 17, single, born in Mexico
Isabella Madina, 30, single, born in Mexico
Maria, 25, single, born in Mexico
Laguda Martinez, 25, single, born in Tucson
Francisca Mendez, 25, single, born in Arizona
Juana Miranoa, 26, single, born in Mexico

WILD WOMEN OF PRESCOTT, ARIZONA

Donaciana Perez, 20, single, born in Mexico
Cathrine Revere, 40, single, born in Mexico
Acencion Rodriges, 35, single, born in Mexico
Sacramenta, 20, single, born in Mexico

While their places of residence are unknown, a better look at these early prostitutes is warranted. Neighbors of Perfecta Gustalo, Isabella Madina and Acencion Rodriges were primarily male miners and laborers. Santa Lopez is noted as being the mistress of "Negro Brown" and was living with a year-old child, Mariana Bran [sic]. None of the women appears in Prescott during the 1870 census, but Rosa Garcia appears in the 1880 census as a "washerwoman."

The 1870 census, conducted in July, outright identifies only five women as prostitutes. Four of them were neighbors, and their households identified them as follows:

N. [Nellie] Stackhouse, age 23, born in Pennsylvania, no occupation listed
M. [Mollie] Sheppard, age 25, born in Ireland, no occupation listed
Maggie Taylor, age 19, born in California, listed as a "Fancy Woman"
Ginnie McKinnie, age 18, born in New York, listed as a "Fancy Woman," resides with Maggie Taylor

The fifth woman, eighteen-year-old Mary Anschutz, is documented as living in the same vicinity as Edward Peck and Joseph Walker, both early mining men who are thought to have been living in the hills just a mile or so from downtown Prescott in 1870. Mary's occupation was listed as that of a "milliner" (two months later Mary, aka Jenny Schultz, would be murdered in Prescott). Although no occupations are shown for Nellie Stackhouse or Mollie Sheppard, later documented history verifies that all three of these women were prostitutes.

Going by house numbers in the 1880 census, at least a few more women in Prescott can be assumed to have been working as prostitutes even though their occupations were left blank. Twenty-three-year-old Nellie Rogers, who was born in Illinois, lived next door to Mollie Sheppard. Also in the vicinity was Elysia Garcia, a forty-year-old woman who lived with six seemingly unrelated Mexican girls. Their ages ranged between sixteen and twenty-eight years. Up the street were Maria Quavaris, Pancha Bolona and Joan Arris. These young women ranged in age from seventeen to twenty-eight years. All three were born in Sonora. Also living with them was an eight-month-old child, Savana Deas, who was born in Arizona.

Wild Women of Prescott, Arizona

Most of the women identified in the census records have their own stories to tell. In broader histories of Arizona, however, their tales are overshadowed by those of the women who accompanied the infamous Doc Holliday and his friends Wyatt and Morgan Earp to Prescott in 1879. Certain historians have a true fascination for the Earps and Holliday and the women each man wooed, dated, married or lived with throughout their lives. Interestingly, most—but not all—of the Earp women worked as prostitutes before or during their unions with the Earp boys.

The purpose of the trip to Prescott was to meet up with another Earp brother, Virgil, who had been in Prescott for over two years and was hired as a night watchman and constable in 1878. The group then planned to move on to Tombstone. To the ladies on the line, there also must have been whispered rumors about the Earp women, whose pasts surely followed them as they swept into town. Most citizens who knew of the Earps, Holliday and their notorious reputations were in awe of them. They were probably in awe of the ladies, too.

The Earp and Holliday women would have been Big Nose Kate, Louisa Houston and Mattie Blaylock. Of these, Kate and Mattie have been presented as prostitutes at some point in their lives, but Prescott inexplicably held no interest for them. Their stay in town was short as they traveled on with their men. Already present in Prescott, however, was Sadie (aka Sada) Mansfield. Certain historians speculate that she really was Sarah "Sadie" Josephine Marcus, who later

A new image purports to be Josephine Marcus Earp. Whether Josie was one and the same as prostitute Sadie Mansfield is still debated among historians. Tombstone Museum.

fell into the arms of Sheriff John Behan of Prescott and Marshal Wyatt Earp of Tombstone. What is known for sure is that Sadie Mansfield worked as a prostitute in Prescott during the 1870s and that at one time she had a relationship with Behan. Like her fellow red-light ladies, Sadie's background is sketchy. But enough information can be gathered about her to form a profile about who this gal might have been.

The earliest known record of Sadie dates to December 1874, when, according to Behan's wife, Victoria, Johnny "did consort, cohabit and have sexual intercourse with the said [woman]...openly and notoriously causing great scandal...all of which came to the knowledge of this plaintiff." Victoria also later claimed she knew all along that her husband had "openly and notoriously visited houses of ill fame and prostitution" since 1873.[59]

Mrs. Behan's account of her husband's actions did not appear until she filed for divorce from him in May 1875. Prior to that, however, Sadie appeared in an article in the *Arizona Weekly Miner*. The story, dated February 5, reported that during the "Grand New Year's Gift Enterprise" drawing, ticketholders gathered at the courthouse to collect their prizes. Among them was "Miss Sadie Mansfield," winner of one of the "principal prizes." The very next day, according to writer Carol Mitchell, Sadie or Sada was arrested for stealing a set of German tablespoons from the store of H. Asher & Co. in Prescott. The spoons were valued at $162, but Sadie was found not guilty. At the time, Sadie was working for madam Josie Roland.[60]

Next came Victoria Behan's accusations against her husband and Sadie when the embittered wife asked for—and received—a divorce from John Behan. Victoria named Sadie Mansfield as one of John Behan's favorite girls from the row, claiming that "the said defendant—has within two years past at diverse times and places openly and notoriously visited houses of prostitution and that he did cohabit with the inmates of said houses of prostitution." She further stated that Behan had sex with Sadie Mansfield. Victoria asked for twenty-five dollars per month in support plus alimony.[61]

In spite of the scandal, Sadie remained in Prescott through April 16, when she retrieved two letters being held for her at the Prescott post office. In November 1879, Behan returned from a visit to San Francisco and opened a saloon at the nearby mining town of Tip Top. Four months later, Josephine Marcus was noted by newspapers as a passenger on a stage arriving in Phoenix from the town of Gillette. A few weeks later, she arrived in Prescott.

Behan was still at Tip Top in June 1880, when the census listed him as a divorced saloon keeper. On the other end of town, some thirty dwellings away, was a "courtesan" named S. Mansfield, whom historians assume was

Wild Women of Prescott, Arizona

Gamblers at Tip Top, Arizona, circa 1880. *Jan MacKell Collins.*

Sadie. The divine Ms. Mansfield also later surfaced in Tombstone, according to other writers, which has furthered speculation about whether she and Josephine Marcus were one and the same. Hard documentation to prove this theory, however, has yet to be produced.

Whatever her association with John Behan and the Earps, Sadie Mansfield was just one of a handful of prostitutes who lived in Prescott during the late 1870s. Women began working on South Granite Street in about 1879; nineteen of them were identified as living there in 1880. Their statistics are interesting. The youngest, Mary Healey, was nineteen years old, and the eldest, Yu Ky, was forty-five. Most of the women were between the ages of twenty and thirty years old. Nine, including Chinese prostitutes, were foreign born. Four out of five of the Chinese women lived with men.

Also, four women had small children living with them. One of them was Mollie Martin, who operated out of a brothel shared with Mary Smith and Mollie's two-year-old daughter, Edith. Mollie was born in 1856 in New Jersey and told the census taker she was married. Edith was born in Arizona in 1878, and her father was born in Virginia. In April 1878, the *Weekly Arizona Miner* reported that Mollie, along with Willie Beatty and Jennie Warren, had appeared in court on assault and battery charges. The

This 1895 Sanborn map shows individual brothels labeled as "dwellings," plus the large Chinese bordello next to Ann Hamilton's old place.

threesome pleaded guilty and was fined twenty-five dollars each. "The fines were paid," concluded the paper, "and the damsels discharged."[62]

Along Prescott's notorious "Whiskey Row" on Montezuma Street, only two prostitutes appear in the 1880 census. One was Mary Dunphy, the prostitute who was listed as a "visitor" at the home of Frank Constable

Murray. The other was fifty-two-year-old Amelia Stevens, a German immigrant. Amelia was listed as living with Leonard Hale, a twenty-five-year-old married barkeep. Whether Amelia, who was a widow and appears fairly old for her profession, was a guest or a permanent resident is unknown.

Most interestingly, a couple of prostitutes were also identified on Alarcon Street, located three blocks from South Granite Street. Their presence there illustrates the city's failure to restrict wayward women to one area in town. On Alarcon, nineteen-year-old Franky Haigh shared a house with twenty-seven-year-old Guan Derby. Next door was twenty-four-year-old Ada Wilson.

By 1900, Prescott had followed the Arizona Territory's decree that cities could designate their own red-light districts. Yet something must have scared Prescott's soiled doves, who declined to identify themselves as prostitutes to the census taker.[63] Rather, the giddy girls of Granite Street were more inclined to list their occupations as seamstresses, laundresses, cooks and other legal but menial jobs. The census taker, who no doubt knew exactly how these women made their money, dutifully recorded whatever he was told by them as far as their ages, marital statuses, places of birth and occupations were concerned.

Only by looking closely at their surrounding neighbors is it possible to discern at least some of the working girls from the respectable women living on South Granite Street. Most of them can be identified by the numbers of houses occupied solely by groups of young women. A few, such as Carrie Neal and Estella Shanks, have been otherwise documented as known prostitutes. But many more of these women remain unknown, appearing only once in the 1900 census with little else known about them.

Going by Sanborn Fire Insurance maps and other resources, Granite Street's loose ladies lived in a variety of dwellings. Some, such as the Japanese courtesan Mamie Miotso, lived alone. Others, such as Iris Bell and Daisy Martin, shared a small house. Still others, including roommates Mary Frankforter, Lena Goffin, Josie Parker and Myrtle Van, obviously worked out of a bordello. Documentation of where these women were from and their living circumstances shows how Prescott was growing; of thirty-two women, seven were listed as born in Japan, while only one was shown as coming from China. Nine others were also foreign born. Most of the women were single, but six others confirmed that they were married and another six others said they were widows. Two were divorced. Eight women had children who were not residing with them.

Of the married women, at least some fell into the category of prostitutes who kept "ceremonial" husbands. These handy men were admirers or

Wild Women of Prescott, Arizona

Most of the naughty women in the 1900 census disappeared from Prescott after that date, forever remaining anonymous. *Jan MacKell Collins*.

friends who married women to keep a respectable and legal appearance. Often, however, they did not live with the ladies but conducted their business elsewhere. Such was the case of Mary Bohlman, who in 1900 told the census taker she had been married for ten years. Her husband, Charles, was not documented as living with her but did show up in the 1903 city directory, where he was listed as a laborer living at 231 South Granite Street.

If husbands were not listed with their prostitute wives, sometimes a customer might get caught by the census taker. Such was the case with Charles Blakey, who was found "living" at the bordello of Flora Freese and Tena Tracy during the 1900 census. Blakey may have just been a passing visitor, for he was better known around Kingman in Mohave County as a local liquor dealer and miner; also, his nickname was the "Cowboy Pianist."[64] In Kingman, Blakey was proprietor of The Snug, a saloon selling wines, liquors and cigars. "Best of Treatment," an advertisement for The Snug read in 1901. "Quiet, orderly house."[65] He was also known as a boxer.

While many of Prescott's prostitutes in 1900 disappeared into thin air after that date, at least a few merit mention. Minnie Moore was documented as being born in Spain in 1861, the year she immigrated to America. She was also a widow with seven children, but only three of them were still living elsewhere. Evidence of Minnie's checkered past came from an incident in Tempe, which the *Arizona Republic* reported on in 1893:

> *Guadaloupe Doe and Minnie Moore were tried yesterday for domiciling within 400 yards of the Normal school building. Being women of easy virtue they made no defense but satisfied the avarice of down traden [sic] laws by depositing $10 and $7.50 respectfully, the amount of costs in the case.*[66]

More is known about Estella Shanks, aka Stella Shank and Bella Shants, as well as Blue Dick and the "Blue Coon." A native of Kansas, Estella was thought to have first arrived in Prescott around 1883. She first appeared in newspapers in 1894, when an article about her exercised a typical tongue-in-cheek attitude toward her arrest:

> *Stella Shank, the colored harlot, who travels under the title of the "Blue Coon," was trotted before Judge Ling today along with Peter Collison as a running mate, for violating the city ordinance which prohibits prostitutes from associating with white or any other men on the streets. Stella plead[ed] guilty when the Judge whitewashed her evil complexion with a $50 fine or as many days. She went down into the alley to "dig up." Collison was*

also assessed $50 but as Stella didn't care to travel anymore with him in the same harness he went to jail to work on the streets without his female companion. The charge against him was that of being drunk, but the combination of her company was such that the judge forgot his customary leniency where poverty usually figures, and gave him a dose that made him also feel blue.[67]

As of the 1900 census, Estella was now forty-two years old and a widow, having once been married to R.M. Fouts. She also said she was from Louisiana. Only one of her seven children survived. With few other choices in front of her, Estella was still turning tricks in the red-light district. Finally, in July 1909, Estella was found dead in her room on Granite Street. She was "sitting on the floor, her head resting on the wall, and the end must have come without any suffering whatever." The *Weekly Journal Miner* commented that Estella had been in bad health for a time and noted she had frequently used a poisonous hair treatment to turn her black hair to a reddish brown.[68]

In Estella's obituary, it was noted that "in gathering up her effects Judge McLane and others who assisted him were somewhat surprised in making the discovery of a sum of money, totaling $326.25 in different points in the room, together with a gold watch and chain and other valuables." The cash comprised silver dollars and paper dollar bills. The newspaper concluded with the statement that "her people have been notified of her death."[69]

One of Estella's contemporaries, Carrie Neal or Neil, also lived in the red-light district for many years. The 1900 census identified Carrie as being fifty-five years of age and born in Montana. Carrie said she was single but also had given birth to a child sometime in the past. The census also verified that she could neither read nor write. Carrie remained in the red-light district for some eighteen years, living at least some of the time at the corner of Granite and Goodwin Streets. From all appearances, Carrie stayed well out of reach of the long arm of the law, the exception being her 1914 conviction for selling dope to Blanche Hardwick. The 1917 *Prescott City Directory* lists her residence as 220 South Granite Street. She was probably still there on November 1, 1918, when she died at the county hospital of chronic nephritis at the age of sixty-five years. It was Maude Brooks, a fellow retired prostitute, who signed Carrie's death certificate. Carrie was buried in the pauper's area of the Yavapai County Cemetery.

Not all of Prescott's wayward women disappeared from record in 1900. Witness Lessie Gerard, whom the census identified as being born in Wisconsin. Lessie was living with her mother and going to school in Chicago

at the time of the 1880 census but did a stint in the red-light district in 1900. A year later, she moved to Tempe with Daniel West, a miner who lived around the corner from her in a Montezuma Street boardinghouse. The couple was married in Tempe on March 11, 1901. The newlyweds eventually moved to Humboldt, where Lessie died in 1909 due to cirrhosis of the liver and "fatty heart." She was buried in the Humboldt Cemetery.[70] Daniel also died at Humboldt, of tuberculosis, in 1911.

Another woman of interest is Josie Parker, an employee of madam Mary Frankforter in 1900. Born in 1881 in California, Josie later left Arizona and moved to Colorado. In April 1915, Sheriff George Birdsall of Colorado City answered a robbery complaint. The victim claimed he had been robbed of approximately $400 in nearby Ramona, a community that was actually founded solely for saloon men and fallen women who had been ousted from Colorado City. The victim's money mysteriously reappeared almost instantly, but a suspect was taken to jail on a $200 bond. Accompanying him were Eula Hames; Josie Parker and her husband, Lon; and Bill English, "alleged frequenters of resorts of this kind."[71]

Beginning in 1903 and for many years afterward, local city directories declined to include prostitutes and other members of the city's more transient population. Because of this, the shady ladies of South Granite appear nonexistent, the exceptions being those whose names appeared in death records or newspapers when they were arrested. But by the time of the 1910 census, new laws actually permitting prostitution within the city limits allowed women to once again identify themselves as working in the industry.

The "restricted" district's growth was evidenced by the number of cribs, brothels, saloons and dance halls that now flourished up and down Granite Street from Gurley and south past Goodwin. And there were four large places that functioned not only as brothels but also as dance halls and saloons. The largest of these by far was Lida (identified as Lotta in the 1910 census) Winchell's. Lida's Place, as it was known, employed fourteen girls. The property included a large hall but also a saloon and a separate outdoor kitchen with a water closet out back.

Lida's biggest competitor was probably Barney Eckstein, a German immigrant who likely had been acquainted with the prostitution industry before he came to Prescott. In 1900, he was living in Salt Lake City with Stella Middleton, who later accompanied him to Arizona. There were eight women working for him in 1910, including Carrie Neal and also four Japanese girls. Also living on the premises were musician Robert Hawley, entertainer G.W. Martin and liquor salesman William Campbell.

This unidentified young lady was a friend of prostitute Gabriell Dollie in Prescott's red-light district. *Courtesy of the Gabriell Wiley estate.*

The next largest place was Grace Watson's with six girls. More is known about the last of the big dance halls, Nick Marini's, located on the site of the Phoenix Saloon that had been purchased from Varney Stephens back in 1900. Born in Italy, Marini immigrated in 1894. By early 1910, he was a bartender in Tucson when he petitioned for citizenship and had moved

to Prescott by the time the proceedings took place on March 18. By the time the census was taken on April 22, Marini was achieving his dream of running a dance hall.

The occupants of Marini's place included Lucy Moline (who may have been his wife, since she was listed as the "head of household"), bartender Jos. Barleggi and five prostitutes between the ages of twenty-five and thirty years old. They were Grace Edwards, a Japanese woman identified as Masossi, Vingnern Love, Frances Mackey and Gabriele Delory. The latter woman was probably Gabriell Wiley, aka Gabriell Darley and Gabriell Dolly, whose interesting life and seemingly terminal husbands made her a legend in Prescott.[72]

A 1912 article about Reverend H.E. Marshall's attempt to convict the women of the red-light district for operating too close to the city hall and the Yavapai County Courthouse named almost all of the district's occupants. Old-timers such as Barney Eckstein, Lida Winchell, Mary (May) Frankforter and Gabriell Dolly were in the mix, but there were also a few newcomers. One was Nora Adams, just lately from Houston. Another was Stella Burke, who just two years before had been working in the red-light district of San Bernardino, California. There was also Marie Harvey, who in 1910 worked at a brothel in Clifton.

Why Nora, Stella and Marie moved to Prescott is unknown, but a bit more light can be shed on another newcomer, May Riggs. Most recently May had been in Globe, where she paid fines for prostitution in 1909 and 1910. In the last instance, May and her co-workers promised to move from their current places on Warren Road. By April, May and her friends were residing in Pinal Wash. Earlier that month, a bill for over $100 had been presented to May by contractor F.W. Tembrook, who was perhaps building a brothel for her at her new locale.

May paid her debt, giving it to Judge Hinson Thomas, who in turn gave it to Tembrook's attorney, Walter G. Scott. The next day, Scott went missing. Foul play was suspected until the attorney was spotted the next day in the town of Rice and other places. Whether the money was recovered remains unknown, but its disappearance could be what inspired May to seek greener pastures.

In the end, the women brought to court in Prescott were released from jail without charges. Most of them were seasoned pros who were accustomed to courtroom procedures. Stella Hughes, however, was the exception. In the months after her arrest, Stella became depressed. Acquaintances claimed she had threatened to commit suicide. In September, Stella was found "in

By 1910, the Sanborn map shows that the red-light district was a busy place, with four major dance halls and several smaller brothels.

the last throes of death," and it was noted that she had been particularly "morose" the last few days. Efforts were being made, according to the newspaper, to find her relatives.[73]

Chapter 5
QUEENS OF THE ROW

Between 1864 and 1918, when the prostitution era of the West as most historians know it ended, a number of women ran houses of ill fame on Granite Street and other places in Prescott. Most of these women were astute business owners, working in an illicit industry that offered more money than other menial jobs as waitresses, seamstresses and laundresses. A madam's earnings did much more than provide a better life for herself, for in addition to making money she also paid fines, license fees and property taxes to the city.

Just who Prescott's first reigning madam was is unknown, but in 1875, madam Josie Roland was noted as Sadie Mansfield's employer. Very little is known about this mysterious madam, who departed as a passenger on the Black Canyon Stage in 1881 and disappeared from record. In time, Josie's name would quickly be forgotten in lieu of several other prominent ladies who ran the roost in the red-light district.

Between 1879 and 1887, Mary Annie Hamilton was most notable among Prescott's madams for her large and somewhat prestigious house on South Granite Street. In February 1879, Annie, with the help of her attorney, Thomas Fitch, purchased Lot 7 in notorious Block 13 from E.W. McNutt. The property was conveniently located across the alley from the back of Whiskey Row, and it is presumed that Annie built her fine bordello there. The building was a large two-story, foursquare house with a well.

Annie financed her endeavor with money she supposedly borrowed from one Archie McBride. What exactly happened between Annie and McBride

Wild Women of Prescott, Arizona

The back of Ann Hamilton's foursquare house is visible in the center of this image. *Jan MacKell Collins.*

is unknown, but in April 1879, the *Prescott Weekly Arizona Miner* mentioned that "Miss Annie Hamilton has commenced suit against Archie McBride for a little crooked transaction."[74] Four months after the suit was filed, Annie furthered her cause by publishing the following public notice:

> *Notice. All persons are cautioned against purchasing or otherwise negotiating a certain note signed by me, for $3,163 dated May 27, 1879, and payable to Archie McBride, on order, at the rate of $100 per month thereafter, with interest at two percent per month, commencing June 27, 1879. And all persons are cautioned against purchasing or negotiating a certain mortgage of even date and amount of said note, and purporting to have been given to secure the same. Said mortgage being upon Lot 7, Block 13 in the Village of Prescott. Said note and mortgage were obtained from me without consideration, and payment of the same will be resisted by me. Annie Hamilton.*[75]

Annie's claim of innocence is up for speculation, since as of July 17, 1880, Archie McBride was listed in county records as the property owner.

Annie was, however, able to reclaim ownership as of August 17 via one Joseph Herspring.

Annie's employees were more refined than other girls on the row. When an outhouse out back was excavated in 2004, the retrieved artifacts included a suede woman's hat, an ornate fan and a fancy chamber pot complete with gold leaf. Also found was a majolica pitcher, a potentially high-dollar item during Annie's time, and a piece of a Staffordshire china dish. Ink bottles indicated that at least some of her girls, or Annie herself, could read and write.

Annie and her girls could also afford such popular patent medicines as Hamlin's Wizard Oil, which was 55 percent alcohol. Other bottles, such as Mrs. Winslow's Soothing Syrup and Dr. A. Bo Schee's German Syrup, contained morphine. Dr. Crossman's Specific Mixture contained opium. All of these items were retrieved from the privy in the back of the house during the 2004 dig.

As far as their personal hygiene went, Annie and her girls were able to procure French perfume, hair dye, Gouraud's Oriental Cream and, in the case of at least one person, powdered toothpaste made by John Gosnell and Company of London. Six toothbrushes

A variety of patent medicines, such as these from the 1897 Sears catalogue, could be ordered by mail.

also were recovered during the excavation. Vaseline made by Chesebrough Manufacturing Co. was likely used both as a lubricant and as a method of birth control.

In spite of their fancy china, toiletries and drugs, visitors to Ann Hamilton's, as well as her girls, appear to have eaten and drunk on a moderate budget. C&I beer was served, along with champagne, wine, brandy and whiskey. Ann's privy also revealed that the occupants and guests of her house ate beef, pork and chicken, the latter two of which seemed to have been the most often consumed.

In 1880, Annie employed five girls at her luxurious brothel, which was the fanciest of its kind at the time. The census lists them as follows:

> Hamilton, Ann, born 1860 in Ireland, married, occupation keeping house
> Martin, Mollie, born 1856 in New Jersey, married
> Carlton, L.L., born 1860 in New York, single
> Elias, Jenny, born 1857 in New York, widow
> Jones, Alba, born 1859 in California, widow
> Healey, Mary, born 1861 in California, married

Also in the house were Mollie Martin's two-year-old daughter, Edith, and Mary Healey's eight-month-old son, Henry. The excavation of Annie's house also revealed marbles and other toys, verifying that the children listed at her place in 1880, and perhaps others as well, once lived on the premises. Property records between 1881 and 1883 show that property owners around Annie's brothel appear to have been male investors, not madams or prostitutes.

In 1884, Annie found herself in trouble again when she apparently leased, borrowed or even perhaps infringed on the property of her neighbor Gus Ellis. Annie had hired the contracting firm of Randal & Cassidy to "make improvements" on the lot but had not paid for the work. Randal & Cassidy subsequently filed a mechanic's lien. In May, Ellis sued the pair for filing the lien without his sanction. The issue was presumably settled, as Annie and Ellis remained neighbors until the illustrious madam died in 1887.[76]

Just prior to Annie's passing, the *Arizona Weekly Journal Miner* reported that someone had stolen "some very valuable diamonds" from the madam, who was "lying at the point of death, having been unconscious for several days." The paper declined to elaborate further on Annie's illness but did note in another article that the diamonds had been recovered by Louis Wollenberg, guardian of Annie's estate.[77] Just a week later, on May 17, Annie died. She

Property owners around Ann Hamilton's brothel, circa 1882. *Yavapai County Courthouse.*

was buried the next day "from the Catholic church," indicating that despite her occupation as a brothel owner, her Irish background permitted her to retain her membership in the church.[78]

Prescott was fairly abuzz over what would become of Annie's substantial estate. An article on May 25 reported that Annie's husband, one Larry

Davis, "was coming to take charge of her property."[79] Davis was apparently unsuccessful, however, because two other men—Patrick Ford and Louis Wollenberg—each applied to become administrators of her estate. Wollenberg won out and in July staged a large estate sale from Annie's bordello. There is little doubt that prospective buyers came from everywhere, if only to gaze upon the interior of a real live parlor house. Besides, there was a lot to see. Newspaper advertisements in July and August listed the goods for sale, to wit:

ANNIE HAMILTON'S ESTATE
7 bedroom sets in black walnut and ash
7 hair top spring mattresses and curled hair top mattresses
100 pounds of feathers in pillows and bolsters
Bedspreads, sheets, pillow cases, pillow shams, white blankets, mottled California blankets, quilts
3 parlor sets
1 piano
2 French-plate mirrors
A variety of oil and watercolor paintings, etchings and steel engravings in walnut and gilt frames, "in endless variety"
Parlor, hall and stair carpets
Cooking and parlor stoves
Trunks and valises
Ice chests
Diamonds, earrings, finger rings, breast pins and other jewelry
Fur cloak and cape
Dresses and other wearing apparel
Dining room and kitchen furniture[80]

Finally, records show that Annie's bordello—presumably empty but for any attached fixtures—was sold in 1889 to none other than Morris Goldwater, who had served as mayor of Prescott ten years before. In all probability, Goldwater continued leasing the house as a bordello. The business was still quite lucrative, as Prescott's first Sanborn Fire Insurance map, published in 1890, shows numerous improvements on the property. An adjoining structure had been built in the back north side, and two other structures were constructed toward the back of the property. These likely served as additional rooming or perhaps a kitchen and storage areas. Goldwater's improvements lasted but a short time, for Annie Hamilton's posh parlor house burned in the Prescott fire of 1900.

Prior to building this parking garage in 2005, archaeologists excavated the site of Annie Hamilton's bordello. *Jan MacKell Collins.*

Annie Hamilton may have kept her wealth private, but everyone knew how wealthy "Diamond May" Ackerman was. Her real name was probably May Applegate when she was born in 1843 in Cincinnati, Ohio.[81] She first appeared in Arizona in May 1880, when she was whooping it up in her own brothel down in Tucson, where she was said to have earned $12,000 in one year. Between 1880 and 1894, she also traveled to San Francisco, where she purchased a diamond cluster also worth $12,000. Next, she was married and traveled to Albuquerque. Somewhere along the way, May's husband must have died since her death record records her as a widow.

May did at least as well in Prescott as she had in Tucson. In 1894, her wealth was estimated to amount to somewhere between $50,000 and $60,000. By 1895, she also was doing time in Phoenix. The *Arizona Republican* reported on her activities: "May Ackerman, a dove not unknown to fame, was yesterday arrested for disturbing the peace." The next day, the paper called May "a young woman of reprehensible character" and noted she had been fined $10.[82]

May's troubles did not end with her escapade in Phoenix. On December 1, 1895, she was back in Prescott, where she apparently went on a binge

Many madams kept their girls honest by using tokens for trade. The modern souvenirs on the left are fake. The ones on the right are real. *Jan MacKell Collins.*

and passed out. As she slept, her jewelry and cash were stolen. For some reason, the theft was not reported for several weeks, when one S.A. Prince fingered the suspects. Three men—Johnny Coyle, Billy Mehan and Charles Phillips—were arrested. The complaint against them claimed that the

> *defendants unlawfully and feloniously did make an assault and by means offered and against the will of one May Ackerman, take from that person of the said May Ackerman the following described personal property, to wit, two earrings, each set with one large diamond and one small diamond, one bracelet made of gold with small watch set in same, one breast pin in the shape of an "S" set with chip diamonds and pearls.*

The value of the stolen loot totaled around $400.[83]

Phillips, already a known troublemaker, turned state's evidence against Coyle and Mehan and was released. Coyle and Mehan awaited a trial, which for some reason was set for many months away, on June 15, 1896. Both men pleaded not guilty. When it was noted that May had not appeared for the proceedings, Judge Hawkins sent Sheriff Ruffner after her. For the next several weeks, the newspapers continued publishing articles about the trial, often with a sprinkling of opinion. It was true: Coyle and Mehan had removed the diamonds from May's stolen jewelry and tried to sell them. The story that the men had actually drugged May so they could steal from her, however, was no more than a theory. Testimony came from sixteen witnesses, including Belle Lee and Lula Davis, the latter of whom was May's sister and was employed to play the piano in May's brothel. In the end, only Mehan was found guilty and sentenced to three years at Yuma's territorial prison.

The trial must have been exhausting for May, who may have been ill. On August 1, 1896, she was found dead. Much sympathy was extended in her obituary, published on the same day:

> *May Ackerman, better known as "Diamond May" died suddenly this morning at her room on Granite Street. A few months ago this unfortunate woman figured in the noted diamond robbery of this city, being the victim and losing it is said several thousand dollars in precious stones in that crime. Her sad ending this morning surrounded by vice and nurtured to the last in extreme poverty, disclosed a life that has surrounded it that which only a courtesan knows. Several years ago she fell through the influence of her womanly charms, and in her conquests became somewhat noted in many places of the east as well as the west, drifting with the tide however until wrecked in the gulf of despair and dissolution. She leaves a sister to mourn her loss and will be laid away tomorrow in Citizens Cemetery.*[84]

May was buried, likely with at least a little ceremony, at Citizens Cemetery. Today, no tombstone marks her grave. Coincidentally, May's sister Lula also

was reported as being "quite seriously ill" on August 12. "The attending physician says that she has strong symptoms of arsenic poisoning," the paper reported.[85] Lula apparently recovered, but her illness may have caused her demise in 1899. In reporting her death, the paper made no reference to May Ackerman and offered only two sentences about Lula: "Lula Davis, a native of Ohio, died in the county hospital yesterday of paralysis. She was a piano player by profession and 30 years old."[86]

Another of Prescott's best-known madams was said to be Lydia or Lyda Carlton, who ran a brothel for many years on South Granite Street. Born in 1860 in New York, Lydia first appeared as L.L. Carlton in the 1880 census, working for Annie Hamilton. Later, Lydia ran her own brothel, possibly remaining in Prescott as late as 1910. Like Annie Hamilton, Lydia's place of business was said to be much finer than the common cribs and brothels along Granite and Goodwin Streets.

Lydia's two-story brothel was fashioned after a hotel with a social room, plus bedrooms in back and upstairs. Customers at her place paid about twice as much as in other brothels. The girls were also referred to as "sporting girls" or "caterers." Lydia's elite parlor house was typical of brothels of its kind throughout the West. Her house served liquor, and customers were expected to purchase drinks while they chose their company for the evening. Once the client chose a girl, he was expected to buy her a drink, which was usually iced tea disguised as something stronger.

Lydia was also noted for requiring her customers to be inspected for venereal disease long before state law required

Wealthy madams, represented here by Mae Phelps of Trinidad, Colorado, aspired to look their best at all times. *Courtesy Colorado Historical Society.*

her to do so. Anyone found to be unfit was asked to leave. Her girls were also required to keep fresh pitchers of water and washbasins in their rooms. Each woman was instructed to wash her customers after transacting with them, resulting in the local joke that "a Peter Pan was a wash basin in a brothel." An employee named Thelma was once noted for having turned in ninety-seven towels, one for each customer during the past week, to the local Chinese laundry.[87]

In very rare cases, prostitutes might encourage their daughters to follow in their footsteps. Pictured here are Denver madam Jane Ryan and her daughters. *Courtesy of Annie Ryan.*

Wild Women of Prescott, Arizona

For the most part, children of prostitutes were seldom mentioned by newspapers or anywhere else. Local newspapers did, however, make the most of the case of Lucille R. Bedford, the three-year-old child of sporting woman Eileen Bedford, in 1908. Born Eileen Glassel Mitchell, Eileen was the former wife of Charles Bedford, a well-known saloon man. The couple had been married in Prescott on July 18, 1901, and lived happily at their home at 232 South Marina Street through 1904. In April of that year, Eileen gave birth to Lucille, the couple's only child.

The marriage did not prove suitable, and the Bedfords divorced in 1906. Charles moved to Los Angeles, while Eileen remained in Prescott. There, she rented Room 16, an apartment above the Wellington Saloon on Montezuma Street. Despite being from a wealthy family and inheriting part of an $800,000 fortune left by her grandfather, Eileen was "well known to the pleasure resorts" of Prescott. But she also was generally regarded as "a woman of excellent education, quiet, unassuming and of rather fine disposition."[88]

No matter her status in society, Eileen grew increasingly despondent after her divorce. By March 1907, little Lucille had been sent to live with her grandmother, and Eileen tried to shoot herself. The gun was taken away from her. On April 9, after a day of drinking, Eileen was escorted to her room by Wellington proprietor B.F. Winn. Both Winn and his bartender tried to talk Eileen out of drinking any more and left. Winn had retired to his room when he heard Eileen groaning. The man rushed back to her room, only to find that she had successfully shot herself in the heart with a Colt .38. Eileen was only twenty-five years old. Her body was removed to Angelus Rosedale Cemetery in Los Angeles for burial.

Eileen's friends puzzled over her death. She had, in fact, been planning to visit her mother, Mrs. Susan G. Mitchell, in Los Angeles. Whether Mrs. Mitchell knew of her daughter's fondness for the demimonde is unknown, but soon after Eileen died, her mother became ill. The grieving woman made a will and bequeathed her $250,000 estate to be divided between Eileen's estate and her other daughter, Mrs. Lucy Lamborne. Susan Mitchell died in December 1907.

A few months later, a lawsuit was filed by little Lucy's guardian *ad litem*. The suit alleged that shortly before her mother's death in December 1907, Lamborne had drawn up another will and made her mother sign it. The new will decreed that Lamborne would receive her mother's house, its furnishings and $10,000 worth of stock in the firm of Lamborne & Sons. Little Lucille would get half of what remained, but later reports claimed the amount was only $5. This suit was apparently dropped.

Giddy girls were often portrayed as gay and happy, but such was not always the case. *Jan MacKell Collins.*

In the meantime, Lucy's father, Charles Bedford, also filed a lawsuit contesting Eileen's will. Bedford also dropped his suit, in January 1909, but resumed his protest a short time later and contested Susan Mitchell's will instead. Bedford lost his appeal in court, although Lucy Lamborne did agree to give half of the fortune left to little Lucy on the condition that she be allowed to adopt the child.

Lamborne got her wish, for the 1910 census recorded little Lucy as living at the Lamborne home in Los Angeles. And when Lamborne died in 1930, her obituary stated outright that she was little Lucy's mother. But the child was long gone from home by then, having married Donald Bryant and relocated to Bakersfield, where she lived with her husband and two sons. Either the family fortune was gone as well, or Lucy Bryant turned her back on it. Census records for 1930 and 1940, as well as various California city directories, indicate that Donald worked as a laborer in the oil fields throughout the southern portion of the state.

Chapter 6
THE STRANGE FATE OF MOLLIE SHEPPARD

Of all of Prescott's wayward women, Mollie Sheppard is probably the best known. Born in Ireland, Mollie was just twenty-one years old when she arrived in Prescott in 1868. Two years or so later, Mollie fell in with William Kruger (aka Krueger), a thirty-year-old clerk who boarded at Maria Wheaton's place in Prescott. Kruger, who was born in Prussia, may have been employed as chief clerk to Captain C.W. Foster, ASM, for the United States Army—for that is how he later signed a letter recounting what is now referred to as the Wickenburg Massacre.

During her time in Prescott, Mollie frequently fought with Yavapai County over taxes. By 1871, she'd had enough, selling her brothel and leaving in November with thousands of dollars in cash. Because much of the real story has been lost to folklore, the amount Mollie carried depends on whom one believes. Newspapers of the day claimed the total to be $6,000, while William Kruger assessed the amount at $9,000.[89]

In addition to her cash, Mollie also allegedly carried her extensive collection of jewelry and was on her way to Panama. This she apparently planned to accomplish by first taking the stage from Prescott to San Bernardino, California, via the Arizona town of Ehrenberg. Boarding the stage on November 4 with her was Kruger, who was working for the Arizona Territory army quartermaster and was transporting $30,000 to $40,000 in military funds to Ehrenberg.

Mollie Sheppard and William Kruger's co-passengers included several other men. They were Boston journalist Frederick Wadsworth Loring, age

Mollie, identified only as "M. Sheppard," appears at the bottom of the page in the 1870 census.

twenty-one, most recently part of the George Wheeler expedition; Peter M. Hamel and William George Salmon, who had been with Loring on the Wheeler expedition and were heading home to their families in California; Charles S. Adams, employed as an agent for W. Bichard and Company, who was traveling to see his wife and three children; and Frederick Sholholm, a

Wild Women of Prescott, Arizona

Prescott jeweler who had sold his business and was on his way to Philadelphia via Panama. The driver was John "Dutch" Lance, who had been working this particular stage road for only two weeks.

"To be sure," Kruger later wrote, "the stage was rather crowded, but being all of such good temper we had a real nice time." The stage traveled through the night, reaching Wickenburg on the morning of November 5. There, according to Kruger, Loring insisted on switching from the inside of the stagecoach to a seat on the outside. "I most decidedly objected," Kruger said, "but he insisted on being outside for a short time. I had two

The optimistic journalist Frederick Loring was photographed in Prescott just before leaving on the ill-fated stage journey. *National Archives & Records Administration 523916.*

revolvers and he had none; in fact, no arms whatever. He rejected my offer of a revolver, saying at the time, 'My dear Kruger, we are now comparatively safe. I have traveled with Lieutenant Wheeler for nearly eight months, and have never seen an Indian.'" Thus, the stage departed, with Loring, Lance and Charles Adams perched atop the coach in the driver's seat while the other passengers remained inside.[90]

The stage arrived at Wickenburg about midnight. The passengers presumably procured lodging and readied to depart the next morning at seven o'clock for Culling's Well, the next station, located some thirty-six miles away. From there, the stage was scheduled to travel through Ehrenberg to the eventual destination of San Bernardino. Once there, the passengers would disperse with at least some of them traveling on to San Francisco via Los Angeles.[91]

All seemed normal within the group. Mollie had spread her fur cape on the middle bench of the coach so the group could play "Freeze-Out," a popular poker game in which players cannot re-buy into the game once they lose their money. The game continues until only one player is left holding the entire pot. Everyone had stashed their guns under the seat cushions to make for easy access to the game.

At about 11:00 a.m., just nine miles northwest of Wickenburg, the stagecoach was accosted by a group of men. Kruger said he heard the driver shout, "Apaches! Apaches!"[92] The men, who were later alternately identified as Mexicans or Anglos dressed as Apaches, rushed the stage on foot as it passed though a canyon and opened fire. William Kruger would later state positively that the robbers were Indians.

In all, seventeen bullets hit the coach. According to Kruger's account, Loring, Lance and Adams were shot. One lead horse was also fatally shot, and the second lead horse was wounded. The surviving horses bolted some twenty yards and came to an abrupt stop. Loring and Adams fell off the stagecoach as the robbers fired again from both sides and the rear. Inside the coach, Sholholm was killed, and Salmon and Mollie were wounded. Salmon fell out of the coach and "crawled away, but was finally captured by the Indians, scalped and otherwise mutilated." Mollie, according to various reports, received anything from powder burns to a gunshot in her arm.

Kruger stated that he and the last uninjured passenger, Hamel, began firing at the Indians. Both men fired six shots. Kruger was out of ammunition when the Indians disappeared behind the bushes. For the next several minutes, there was silence except for moans from Loring, who lay dying

Wild Women of Prescott, Arizona

This early day Arizona stage is representative of the type in which the massacre victims rode. *Jan MacKell Collins.*

directly in front of Kruger.[93] Kruger also had pushed Mollie to the floor. Although "badly wounded," Mollie managed to take a loaded revolver off one of the dead men and hand it to Kruger.

A few minutes later, Kruger saw some fifteen "Indians," dressed in blue soldiers' trousers, creeping toward the stage.[94] Kruger jumped up, and both he and Mollie began yelling at the robbers as Kruger commenced firing again. Mollie later stated that she threatened the robbers with a broken whiskey bottle. The robbers retreated, and the couple readied to make a run for it. Kruger said he called out "as loud as I possibly could if any one was left alive, but only Mr. Adams answered; but he was mortally wounded and could not even move his hands or feet. I had to leave him to his fate." Adams was later found with his throat cut.[95]

Quite by some miracle, Kruger and Mollie were able to jump from the stage and run toward Culling's Well on foot. According to Kruger, he received a gunshot through his right armpit and two shots to his back. Mollie, he said, was shot three times. It is unclear whether these wounds were sustained at the coach or while on the run. As the couple fled, some of the robbers came after them on horseback which resulted in "unsteady" gunfire. Later accounts would claim that "only a slight wound was received

by Miss Sheppard, and neither [she nor Kruger] sustained further injury than the wounds inflicted from the first fire."[96]

It is a miracle Kruger and Sheppard were not overtaken; instead, they were saved by the shots Kruger fired as they ran. The hapless man "still retained his revolver and fired upon them when they came too near, causing them to scatter and retreat but only to rally again to the pursuit until finally they withdrew and joined their fellows."[97] According to Kruger, he carried the "wounded woman for over two miles in my left arm" and said the Indians chased them for five miles. He also said he shot at least two Indians, who later died at Camp Date Creek Reservation. Camp Date Creek had in fact been established in 1866 as a military post between Prescott and Ehrenberg to protect travelers in peril. Kruger later shed a different light on the camp, claiming that commanding officer Captain O'Beirne of the Twenty-first Infantry "not only allowed the Indians to go unpunished, but also refused me, Miss Shephard [sic], the two surviving cripples, shelter. Yes, sir, he ordered us off his reservation."[98]

At last, Kruger and Sheppard spotted an eastbound mail carrier who had just left Culling's Well. In one version of what happened next, the driver "made them as comfortable as possible and rode one of the horses back to Wickenburg for help."[99] In another version, the driver took the couple back to Culling's Well. Word was sent to Wickenburg via the Vulture Mine, "the bearer fearing to proceed by the direct route." As a result, news of the attack did not reach Wickenburg until midnight. Meanwhile, a full sixteen hours "of terrible suffering and agony" after the attack, Kruger and Mollie were finally taken to Wickenburg.[100]

Two groups left for the site of the attack: one to claim the bodies and another to track the killers. When the parties reached the stagecoach, they were met by the horrible sight of the bodies of Loring, Adams, Lance, Sholholm, Salmon and Hamel. The latter two men had been shot, and Hamel was so badly mutilated that he was buried on the spot. Curiously, although the passenger's bags had been broken open and some items were missing, other large sums of money and valuables remained at the scene. Even ammunition and horses, which would have typically been taken if the marauders were Native Americans, remained. But the money allegedly belonging to Kruger and Mollie was gone.

Kruger later recounted that he accompanied the parties to the massacre site, "closed the eyes of all my poor traveling companions" and retrieved Loring's hat, which he later offered to the writer's grieving family. The remaining bodies were buried the next day "in nice coffins." As for the

assailants, they were tracked by the party from Wickenburg to the Camp Date Creek Reservation. "The commanding officer refused to have the thing investigated," Kruger later claimed of Captain O'Beirne, "for fear we would find sufficient evidence that they were his pets—that is, the Camp Date Creek Indians."[101]

The sensational story of the Wickenburg Massacre quickly became national news. On December 9, William Kruger wrote a letter from Ehrenberg in response to a request for information from the eastern relatives of Frederick Loring. In it, Kruger gave intimate details of the escapade. The letter included Kruger's statement that the men were buried at the site of the massacre, but other reports were made that five of the victims were "reportedly buried in Wickenburg on November 6th, three hours after a hastily called inquest." If this were true, the bodies would have been buried at Stone Park Cemetery or Lumber Yard Cemetery, the only two burial grounds in existence at the time.[102]

An initial outcry almost led to a complete massacre of the Indians at Date Creek but for the intervention by General George Crook from Fort Whipple. The authorities continued investigating whether the robbers were indeed the Native American inhabitants of Camp Date Creek. History has since confused whether the residents at the camp were Apache-Mohave Indians or Yavapai Indians. What has been ascertained by at least one historian is that Captain Charles Meinhold and twenty other men left Camp Date Creek to join the search for the murderous robbers. Adjutant Captain Azor H. Nickerson later reported that the group was unable to "determine definitely whether the perpetrators were Indians or Mexican bandits or both."[103]

For months, speculation ran amok about who actually committed the crime. The suspects ranged not only from the Indians at Camp Date Creek but also to Mexicans led by Arizona outlaw Joaquin Barbe, a bunch of unidentified crooked military officers and even Anglo men from Prescott who knew there was a lot of money on the stage. Sentiments ran high that the Indians were in fact the murderers, but eventually William Kruger and Mollie Sheppard also were suspected of pulling off the robbery themselves. When lack of evidence set them free, the couple went to California, where they received celebrity status. On January 3, 1872, the *Los Angeles Daily News* ran an article consisting of an interview with the couple, who claimed they each lost $8,000 to the robbers. Back in Prescott, however, the *Weekly Arizona Miner* was still accusing Kruger of slander and lying as late as February.

In the meantime, General George Crook continued his investigation. There was ultimately a skirmish at Camp Date Creek that resulted in the

killing of two Indians. Another was arrested. In addition, Phoenix deputies went after Joaquin Barbe and his gang. The leader and another Mexican were "escorted" out of town and subsequently "shot to death by the deputies during an argument." Other Mexican suspects met their ends in jail and at the hands of others.[104]

In the end, the murderers from the Wickenburg Massacre never were identified. In April 1874, Kruger told others that Mollie had died from her wounds but gave no other information. It is presumed she died sometime after January 11, 1872, the date she was last seen with Kruger in San Francisco. Where and how Mollie died, however, remains a mystery. To historians, Kruger has in fact remained a suspect in the killings if only due to the mysterious disappearance of his companion. What happened to Kruger is equally mystifying, for the man himself also disappeared.

In 1937, the Arizona Highway Department erected an official plaque in memory of the victims of the Wickenburg Massacre. Eleven years later, in March 1948, the Wickenburg Saddle Club made its first trek to the massacre site. The club found five of the graves and erected a marker and a plaque, neither of which survives today.[105] The Wickenburg Saddle Club placed a second plaque at the site in 1988. Today, the graves (if they are still really there) of those who died at the Wickenburg Massacre are marked near

The Wickenburg Massacre site as it appears today. *Courtesy Al Bossence.*

where the robbery occurred. Those who are allegedly interred there include Frederick Loring, C.S. Adams, John Lance, Fred Sholholm, W.G. Salmon and P.M. Hamel. Curiously, a seventh grave was identified by the Saddle Club as being that of a woman.[106] In 2011, a different marker commemorating the massacre was identified as being located near the airport, three and a half miles from the site.

So, what really happened to Mollie Sheppard? The Wickenburg Saddle Club has a theory that Mollie and Kruger had enough time to gather their valuables before escaping the stagecoach, burying them as they fled from the robbers. Returning to the site sometime later, the club speculates that Kruger killed Mollie and buried her with the others. Or perhaps someone else killed Mollie. Whatever really happened to her, Mollie took the truth about the Wickenburg Massacre to her grave.

Chapter 7
LIDA WINCHELL, FROM RAGS TO RICHES TO RAGS

Prescott madam Lydia Carlton has often been confused with Lida Winchell, who has her own interesting story to tell. Both women are credited with running the fanciest bordellos in town. Going by various descriptions, both women reigned over the same pleasure palace. Over time, both women were alternatively known as Lotta, Lyda and Lydia. Lida Winchell's last names included Farrell, also spelled Farrow, and Duff. Her frequent change of names may be why she has been associated with the more enigmatic Ms. Carlton.

What is known for sure is that Lida Winchell's name was Eliza Jane Crumley when she was born on October 6, 1876, in Georgia to Charles and Sarah Crumley.[107] By 1880, the Crumleys had migrated to Kingman, Kansas, along with Charles's very large family. His father, Benjamin, as well as some of his older brothers and Charles himself, worked as farmers in Kingman. Being the only Crumley son who was married at the time, Charles lived in a separate house with Sarah, Eliza Jane and another daughter, Josephine, who was but nine months old.

The family stayed in Kansas through at least 1885, and Charles and Sarah had three more children. In about 1890, they migrated with the rest of the family to Pueblo, Colorado. Three years later, Eliza was going by her nickname, Lida, and working as a domestic servant for Elmer Ringer. Her parents lived across town at 1404 Evans. Lida was still in Pueblo as late as 1899, when she was listed as renting furnished rooms at 1–2 South Union Avenue. Lida's house was in proximity to Pueblo's red-light district,

| J. R. GORDON INVESTMENT BANKER. Room 3, Board of Trade Building. | FINE HOUSES ON EASY PAYMENTS AND INSIDE PROPERTY A SPECIALTY. |

CRO 191 CUL

Crowe Wm., C F & I Co r 621 Routt Bess
Crowell Alferd N., contractor and builder 1117 E 8th r same
Crowell Wood, wks Rocky Mountain Oil Co r Overton
Crowl M. L., lab C F & I Co r 1307 Elm Bess
Crowley Mrs. I. N., r 1617 W 8th
Crowley James, track foreman A T & S F Ry yards r 701 W 7th
Crowly M., inspector D & R G Ry r 38 blk X Corona Park
Cruggs Chas. D., cigar maker W T Flager r Holden blk No 2
Cruggs C. F., wks Colo S Co
Crumley Chas., r 1404 Evans Bess
Crumley Lida, domestic Elmer O Ringer r 319 W 7th
Crummedy Wesley, (col'd) porter Hyman Levin r 310 W 4th
Crump Henry, waiter Grand hotel r same
Crunk Wm., lab C F & I Co r 1319 E Abriendo
Cubic John, baker Wm Ihrig r 1124 Routt Bess
Cuchevar Frank, wks C F & I Co
Cuddeback Frank L., sec and tres Pueblo Electric Co r 219 E 7th
Cuffle —, driver Star Transfer Co I B Culbertson mgr r 826 E 5th
Cukovcack S., wks Pueblo S & R Co r Tenderfoot Hill
Culbertson G. A., driver Star Transfer Co r 813 E 4th
Culbertson Ithamer B., mgr Star Transfer Co r 813 E 4th
Culbertson Sam, r 1023 Routt Bess
Culbertson Wm. N., teamster r 811 E 3rd
Culeg Joe, brkpr M Egan r 1202 S Santa Fe
Cullen John, policeman r 203 E 4th
Cullings Andrew L., r 21 blk O Corona Park
Cullings Belle, teacher So Pueblo Schools r 21 blk O Corona Park
Cullings J., chainman city eng r 21 blk O Corona Park
Cullison S. D., transfer D & R G Ry r 309 Polk
Culver Chas., switchman U P Ry r Pueblo Smelter hotel
Culver W. W., supt Wrought Iron Range Co r 2530 5th Ave Central Park

The Pueblo Distilled Water Ice and Cold Storage Co., MANUFACTURERS AND WHOLESALERS OF ARTIFICIAL ICE, NOS. 711-737 W. 7TH ST., PUEBLO, COLO.

BENSON & KIRTLAND — INSURANCE, LOANS AND INVESTMENTS.
Rooms 17 and 18, Swift Blk., Pueblo, Colo. All Losses adjusted and paid at this office

Lida's name appears in the 1893 Pueblo directory just below that of her father, who lived across town.

although there is no evidence that Lida practiced prostitution there. There is every chance, however, that Lida was influenced in her decision to turn to prostitution by her uncles Sherman, Grant and Newton Crumley.

In about 1894, the three Crumley boys moved to the booming Cripple Creek District, located roughly fifty miles from Pueblo. In its time, the district was in the midst of one of the most famous gold booms in the United States. By 1898, Cripple Creek's gold production had surpassed that of the famous California gold rush and generated over thirty millionaires to boot. It was the perfect place to make a little money.

Sherman Crumley especially made a big splash during a tumultuous labor war that took place in the district in 1894. Young Crumley was pinpointed as one of several men who kidnapped, tarred and feathered Adjutant General Thomas J. Tarsney in Colorado Springs. Tarsney was on his way to Cripple Creek to lobby on behalf of the striking miners.

Later, Sherman allegedly married prostitute Nell Taylor and helped form a gang that specialized in robbing stages, trains and wealthy men. Meanwhile, Lida's uncle Grant worked at various saloons in Cripple Creek and would watch for men spending large sums of money. Upon finding a potential victim, Grant would quietly notify his cohorts, who would later rob the unsuspecting prey once he had left the establishment. Grant also was known for his relationship with one of Cripple Creek's notorious prostitutes, Grace Carlyle.

Cripple Creek's expansive red-light district spanned Myers Avenue, just one block south of the main drag. *Courtesy Cripple Creek District Museum.*

The Crumley boys' illicit activities occurred in the Cripple Creek District's formative years. By 1901, Grant was running the roulette wheel at the prestigious Newport Saloon in Cripple Creek. One night, Sam Strong, one of the town's newly made millionaires, accused Crumley of running a crooked wheel. The man pulled a gun on Crumley, who reciprocated by pulling out a shotgun and shooting Strong in the head. The millionaire died a few hours later.

Crumley was eventually acquitted, but the incident made national headlines. Favoring a fresh start, the Crumley boys moved on to Nevada in about 1903. Today, they, along with their descendants, are credited with running some of Nevada's earliest casinos and introducing celebrity entertainment to the gambling industry. Newton's son, also named Newt, later graduated from the University of Nevada in 1932 and was commissioned a second lieutenant in the U.S. Army Air Corps.

For at least a short time, Lida also lived in the Cripple Creek District. Just prior to migrating to Arizona, she resided in the district city of Victor. In all likelihood, Lida spent at least some time with her notorious uncles before leaving town. She is thought to have arrived in Prescott just before the great fire of 1900.

The first mention of Lida in Prescott was in the *Arizona Weekly Journal Miner*, which reported she had departed for Albuquerque in July 1901. In fact, Lida may have merely gone on a scouting mission for employees, for soon she had one of the fanciest parlor houses on South Granite Street. Lida "liked the frontier life of Prescott, and here she remained."[108]

By the early 1900s, "Lida's Place" at the corner of Granite and Goodwin Streets was one of the most popular party spots in Prescott. Her large property included not just a parlor house but also a saloon, a separate building that served as a kitchen and a "water closet" out back. Cheaper "cribs" were located next to the parlor house, along with a small bordello on the other side. Lida quickly became known as "the proprietress of the most extensive gambling and drinking emporium in the Southwest."[109]

Lida's friends and admirers later attested to her grand bordello. At any given time, she had fourteen well-dressed women working for her. In the large house was a parlor where the girls could chat with customers before getting down to business. It was widely known that the clients were expected to buy drinks for themselves and their ladies of the evening. For each drink purchased, the girl received a "bar chip." Later, the girl would cash in her chips to Lida, who received a percentage of the profit. The price for sex was two dollars.[110]

Victor, Colorado, the fifth-largest city in the state in 1900, was probably one of the biggest metropolises Lida had ever seen. *Courtesy Cripple Creek District Museum.*

Victor, Colorado, the way it looked when Lida left town for Prescott. *Jan MacKell Collins.*

For over ten glorious years, Lida reigned supreme in the red-light district. She also made a lot of money staking prospectors. At Lida's, "a man could find a stake for a new mining claim when all other channels were closed. Lida was like that. She took money from men…and then gave it back to those whose luck had hit a bad streak."[111]

Lida's large property is visible at 1–8 South Granite Street on the 1901 Sanborn Fire Insurance map.

Lida also loved diamonds. At one point, it was said she "had more diamonds than most banks had money in their vaults." Within a few short years, she had amassed a "fortune estimated at one time at several hundred thousands of dollars—mostly in diamonds." Once, a man borrowed $100

in gold from her to invest in mining. The gentleman struck it rich within two months and paid Lida back, with a most generous bonus. Lida used the money to purchase a $10,000 diamond from a wealthy gambler she knew.[112] In fact, her extravagant love for the precious stone earned her the nickname "Diamond Lida."[113]

In 1907, Lida married for the first time. Her chosen mate was Walter Farrow, whom she wed on April 2 in Prescott. There is no record of their living together, and Walter Farrow does not appear to have ever lived in town.[114] As with so many other madams and prostitutes, Lida's husband was apparently "ceremonial." The marriage did not last. When the 1910 census was taken, Lida (whose name was spelled Lotta by the census taker) listed herself as single at her place at 212 South Granite Street. She had fourteen girls in her employ, each identified by the census as prostitutes.

> LIDA WINCHELL'S EMPLOYEES IN 1910
> Edith Roberts, age 23, born in Missouri 1887, single
> Irene Carson, age 26, born 1884 in Germany, immigrated 1885, single
> Annie Shipley, age 28, born 1882 in Texas, single
> Grace Wilbur, age 20, born 1890 in Missouri, divorced
> Laura Gordon, age 28, born 1882 in California, single, father born France, mother born Ireland
> Mamie Brooks, age 31, born 1879 in Kentucky, single
> Bessie Rorabaugh, age 31, born 1879 in Ohio, single
> Blanch Dune, age 34, born 1876 in Belgium, single
> Browney Garcia, age 24, born 1886 in California, single
> Helen Everett, age 28, born 1882 in Canada, single
> Dolly Everett, age 26, born 1884 Canada, single, sister of Helen Everett
> Lizzie Smith, age 36, born in Colorado 1874, single
> Daisy Ford, age 28, born 1881 in California, single
> Jospehine Gardner, age 26, born 1884 in Texas, single

Of the last two women, at least a little is known about Josephine "Josie" Gardner. In June 1913, she married Sylvester B. Durfee, a rancher from Castle Creek. For whatever reason, the union lasted only a few days before Josie unaccountably returned to the red-light district. The following November, in the early hours of the eighteenth, she attempted suicide by taking several tablets of bichloride of mercury. Prostitutes occupying nearby rooms "were startled by agonizing cries coming from the girl's chamber." Upon entering the room, the women found Josie "rolling in agony upon the floor." A doctor was

summoned, pumped the poison from Josie's stomach and used several antidotes.[115]

Little else was known about Josie, including how long she had been "on the line." It was noted that her marriage apparently "would not permit reform at such a late date" and that she refused to give a reason for her suicide attempt. The newspaper held little hope for her recovery, although nothing more was reported about her and there is no record of her death.[116] She also never returned to Durfee, who remarried in 1914 and again in 1917 and fathered several children. What became of Josie remains unknown, although some 1919 news articles identified a woman by her name who was working as a professional singer.[117]

The little dance hall girl depicted on this 1908 postcard could hardly be used to describe Lida Winchell's girls at her Prescott dance hall. Jan MacKell Collins.

Daisy Ford is also notable since she was working in Victor, Colorado's red-light district as of the June 1900 census. It is entirely possible that Lida knew Daisy when she was in Victor and equally possible that Daisy followed Lida to Prescott.

Although she considered herself single when the census was taken in April, Lida did not file for divorce from Walter Farrow until July. She was legally single and still in business when she was arrested, along with other denizens of the red-light district, in June 1912. Like the others, Lida's case was dismissed, but her name made the papers once more in 1913. That time, city officials who were confining ladies of the red-light district to the west side of Block 13 on South Granite Street pointedly made an exception for Lida's Place because it was located just outside

On the 1910 Sanborn map, Lida's Place had a prominent spot in the middle of Goodwin Street at the corner of South Granite.

the district. At the time, in fact, Lida's Place practically sat right in the middle of Goodwin Street some yards from the intersection of South Granite Street.

In spite of the city's generous gesture, Lida decided to retire in 1913. Her savings amounted to some $400,000 in cash and her beloved diamonds. And besides, she had found love in her life. By the time the city directory was published in 1913, Lida had married bartender Lawrence Duff, who worked for the Birch Brothers Saloon. Larry, as he was best known, was no stranger to the red-light district. Newspaper accounts of the day show that he sold two automobiles: one to fellow bartender Leonard Topp in 1913 and one to Topp's girlfriend, Gabe Darley, in 1914.

By 1916, the Duffs had moved from the center of the red-light district to a house at 146 North Granite Street. Duff continued working for Birch Brothers, where he was arrested in August for "bootlegging" and again in 1918 for violating the Prohibition amendment. In the latter case, he served some time in jail but was paroled, taking up a new vocation as an electrician in 1919.[118]

Even as her husband continued working on Whiskey Row, there is nothing to indicate that Lida continued working as a madam. By 1920, the couple

According to the Yavapai County assessor, the Duffs' first home on North Washington has since been replaced with this house. *Jan MacKell Collins.*

had relocated farther away from the red-light district. With Lida's money, they moved to a new home on Washington Avenue, an elite neighborhood in Whipple Heights in what was then the outskirts of town. Larry Duff went to work for the city's water department as a meter reader, while Lida settled into life as a domestic housewife.

From all appearances, the Duffs lived a quiet, humble life for the next several years. Notably, Larry Duff built up a reputation in town as "the nation's Number One baseball fan," an accolade he received for faithfully attending the World Series games each year. There is little doubt that Lida's wealth financed her husband's annual trips to Chicago, Boston, New York and wherever else the games were taking place.[119]

At home, Duff also worked his way up at his job. By 1923, he was foreman of the water department. And in 1934, the couple built an all-new home next to their old one. But all was not bliss in the Duff household. In about 1935, after twenty-two years of marriage, Larry and Lida Duff divorced. In October, Larry remarried to Miss Tillie Grates of California.

For the next few years, Lida disappears from record. There is little doubt that she was deeply hurt, knowing that Larry Duff and his new wife now occupied the home Lida herself had paid for. With her wealth squandered on her marriage and World Series games, she was forced to return to her old haunts in the former red-light district, renting a small room on South Granite Street—less than half a block away from her once luxurious bordello.

Later, Lida was forced to move again when the city, seeking to beautify the now dilapidated red-light district, tore down the building she was living in to build Jefferson Park. Her last home was another room on Goodwin Street, in the same neighborhood, in full view of the vacant lot where "Lida's Place" once stood.

Larry Duff also suffered setbacks. In 1937, he was asked to resign from the water company for failure to care for a new sewer plant. Duff was forced to go back to his former vocation: bartending. Then, in June 1938, he contracted pneumonia and died.

In the end, his estate was worth a paltry $1,500, an amount that included the house on Washington Avenue and $100 worth of jewelry and other items. The new Mrs. Duff got everything. Not only that, but she also began courting a man named Percy Bigger, whom she would later marry.

In the meantime, Lida's return to the old red-light district was worsened by those who saw her as nothing more than a "white-haired, enfeebled old woman." Although she still had a few friends from the old days, to many residents Lida was "a pitiful figure in tattered clothing that shuffled through

Lida is believed to have paid for the construction of her second house on Washington Street, only to lose it in her divorce from Larry Duff. *Jan MacKell Collins.*

the streets selling pencils and handwoven shawls. As they bought her wares, they often had wondered why she was called 'Diamond' Lida. In her wrinkled and care-burdened face were the deep etchings of privation and hunger."[120] Quite a sad description considering Lida was only sixty-three years old.

On the night of April 4, 1939, Lida took her customary stroll down Whiskey Row. There, she ran into some old friends who were going to a party at a miner's cabin on Little Copper Creek, roughly ten miles outside Prescott. Lida went, too. Early the next morning, a hitchhiker "found her wandering aimlessly and in a stupor" on the road to Little Copper Creek. She was trying to get into an "old automobile" on the side of the road. The stranger helped her into the vehicle and went on his way. That was the last time anyone saw Lida alive.[121]

The following day, Lida's body was found in the front seat of the car. It was guessed that she had succumbed to "natural causes, exposure and liquor."[122] News of her death included a small tribute to her, memorializing her as "a character from days-gone-by; days when Prescott was a booming mining city where men made fortunes on rich ore claims and lost them on

the spin of a wheel, the turn of a card and for the smile of a pretty girl."[123] Lida's sister Josephine was notified in Pueblo. She visited Prescott just long enough to arrange for the cremation of Lida's body and instructed the ashes to be sent to her.

Lida may have been remembered by some as the belle of the ball in her day, but there were others who harbored a different memory and, unfortunately, acted on it. In the days following the lady's death, certain old-timers suddenly remembered why she had once been known as "Diamond" Lida. Stories soon began circulating about how Lida had once walked the streets with hundreds of thousands of dollars in glittering gems adorning her clothes, fingers, arms and neck. Some remembered seeing her buy diamonds "as big as your thumb" from gamblers and wealthy travelers.[124]

The stories grew in leaps and bounds, including the ludicrous rumor that she was driven to murder when she saw a piece of jewelry she wanted to have. City officials didn't help when they revealed the discovery of a diary on Lida's body. The notebook told of her life, loves and career and also gave intimate details of her diamond purchases. In all, according to the book, Lida had bought 342 diamonds, the largest gem being fifteen karats. A handful of scavengers concluded that the woman's fondness for diamonds was like a drug habit she could not break. Surely she had held on to each precious stone even as she lived in poverty.

Soon, a horde of "eager diamond-searchers" converged on the site of "Lida's Place." Only crumbling foundations and piles of wood remained, but the scavengers, armed with digging tools, worked tirelessly in their quest to find Lida's "hidden" fortune. Another bunch descended on the shack Lida had called her last home and were only prevented from destroying the building by local officials. Even places Lida was slightly rumored to have lived, many of which were now just vacant lots, were upturned in the frenzy, which lasted about three days. For at least a few years, the legend of Lida's diamonds continued. No hidden cache was ever found.[125]

In 1976, workers were grading the site of "Lida's Place" to make way for a new junior high school when a longtime resident happened by. "What's that going to be?" he queried. One of the construction workers answered that they were going to build a playground. "Hell," replied the elderly man, "that's all it ever was."[126]

Chapter 8
In Defense of Gabriell Dollie Wiley

One of America's most famous prostitutes came from Prescott. Far beyond her stint as a leading madam in town, however, Gabriell "Gabe" Wiley is remembered on quite a different level. In 1915, she made national headlines for the killing of her former abusive lover in a Los Angeles liquor store. Ten years later, she became the first person to sue a motion picture company over privacy rights. The two incidents made Gabe a heroine of sorts in her time, but unfortunately, a third aspect of her life has labeled her as a cold-blooded "black widow": every one of Gabe's husbands came to a most unusual end.

If Gabe was actually guilty of anything, it was most certainly having bad taste in men. Writers have been particularly fond of preying on her due to the numerous sets of strange circumstances that constantly put her in a questionable light. In fact, Gabe's story has at times turned into blatant fiction to the extent that nobody has even put a definitive finger on her humble beginnings. Only the most stalwart historians have been able to agree that she probably was born Gabriell Layral on March 31, 1890, in Italy.

Gabe herself said she and her parents came to New York when she was but one year old. Her father died soon after, and her mother was working as a seamstress when she moved with Gabe to San Francisco. There, mother and daughter eked out a meager living while occupying a small room. Later, Gabe worked as a maid for an Italian couple. Gabe and her mother were still in San Francisco when the legendary earthquake of April 18, 1906,

WILD WOMEN OF PRESCOTT, ARIZONA

This image, circa 1902, is believed to be the earliest picture of Gabe Wiley. *Courtesy of the Gabriell Wiley estate.*

destroyed much of the city. The women survived the quake itself, but Gabe later said her mother died in the devastating fires that followed.

At the tender age of fifteen, with no other family in America, Gabe was left to make it alone. She first hitched a ride to Oakland with an older woman before catching a wagon heading east to the Nevada gold fields.

Of the thousands of people displaced in the wake of the San Francisco earthquake, Gabe's mother was one who disappeared in the aftermath. *Jan MacKell Collins.*

Once there, Gabe was forced "into the life of the submerged."[127] She began cruising from gold camp to gold camp, waiting tables by day and working as a prostitute by night. At the infant town of Las Vegas, Gabe met and married her first husband. But the husband, whose name remains a mystery, was shot to death in about 1908, and Gabe was forced to move on.

Traveling to Prescott, Gabe quickly found work as one of the soiled doves along Granite Street and Whiskey Row. In 1909, she was married again, this time to Ernest Presti, at the mining town of Congress. In Arizona boxing rings, Presti was known as the third-rate prizefighter Kid Kerby. He also was a gambler

Wild Women of Prescott, Arizona

This formal portrait of Gabe is one of a series and likely dates to about 1910. *Courtesy of the Gabriell Wiley estate.*

who was better at losing Gabe's money than winning. During his marriage to Gabe, Presti once was arrested for "beating a female habitué" of the red-light district, and most historians speculate that the victim was Gabe.[128]

Whether or not Gabe was Presti's victim, she'd soon had enough and left him in 1910. When the census was taken on April 22, she was working at Nick Marini's place at Granite and Gurley Streets. Gabe told the census taker that she was single and that her last name was "Delory."[129] Her divorce from Presti, which she filed on grounds of desertion and nonsupport, was granted on November 8.

Presti had in fact been seriously injured in Tucson just prior to the divorce, but by May 1911, he was back in Prescott and bartending at the Union Saloon. Going from an inscription on the back of a photograph of Gabe around that time, she may have been living at Crib #3 on Goodwin Street, just around the corner from the Union. She may have even been present one night when Bill Campbell, a fellow prizefighter who had lost more than one fight to Presti, came into the Union. Campbell began playing blackjack, but the cards weren't in his favor. At the end of the evening, Campbell paid his twenty-dollar gambling debt by check, grumbling something about the game being crooked.

By the time the check was presented for payment at the bank the next morning, Campbell had in fact stopped payment. The following day, Presti snuck up behind Campbell as he stood in front of Barney's Place, another saloon located across the street from the Union. Presti "struck the negro behind the left ear with a pair of 'knucks,' escaping into the saloon."[130] The blow was not enough to fell Campbell, but he did wait outside the place until night officer Thomas McMahon appeared. Both men immediately began appealing their cases to the policeman, who told them to quit fighting and go get warrants if they wanted to settle their differences.

Three days later, Presti was in front of the Palace Barbershop on Whiskey Row. Without warning, Campbell suddenly ran up from behind and shot Presti in the back. The injured man ran across the street but fell at the curb in front of the courthouse. He died in less than three minutes. Night officer John Hudgens of Jerome, who happened to be visiting the courthouse and saw the incident, arrested Campbell.

"Eye witnesses pronounced the shooting among the most cold-blooded in the history of Northern Arizona," declared the *Prescott Weekly Journal Miner*.[131] Presti's death certificate verified that it was Campbell who fired a .38 Iver-Johnson five-shot pistol at Presti and killed him. Certain writers, however, later tried to insinuate that Gabe had something to do with the

The back of this image of Gabe identifies it as being taken at "No. 3, Goodwin, Union Saloon." *Courtesy of the Gabriell Wiley estate.*

murder. But it was Campbell who was sentenced to hang—although his sentence was later commuted to life in prison.

Gabe remained in Prescott, largely out of the limelight until she was arrested (under the name Gabriel Dollie) during Baptist Reverend H.E. Marshall's attempt to shut down the red-light district in 1912. The case against her was dismissed.

Around the same time, Gabe fell in with Leonard Topp, a striking middle-aged man of Canadian and Chippewa descent. Topp had only

recently received an honorable discharge from Fort Whipple. In 1913, he was bartending at Birch Brothers Saloon while living in one of the upstairs suites at the Palace Hotel. Gabe was probably living with him, for it became commonly known that Topp was her pimp and that the couple began living together about that time. During their four years together, Topp took roughly $15,000 of Gabe's earnings and beat her on a regular basis.

Unfortunately, Gabe was a willing victim. When Topp was accused of embezzling money from the local bartender's union, Gabe paid it back to

Inside Gabe's room, possibly at her Goodwin Street address or when she lived with Leonard Topp. *Courtesy of the Gabriell Wiley estate.*

save him from jail. He also once forged a check in her name, but she refused to press charges. And despite the beatings he gave her, Gabe willingly accepted when Topp proposed marriage. But on a night in 1915 after Gabe went to work, Topp unexpectedly left for California. He tried to mortgage Gabe's property on the way out of town but was unable to do so. He did, however, make off with her diamonds.

Brokenhearted, Gabe became a woman possessed. It took two trips to California and several inquiries before she finally located Topp in Los Angeles. She also learned he had left her for another woman, Bonnie Elliott. Gabe later testified, "When I got [to Los Angeles], I saw him with another woman. I tried for some time to get him to talk to me, but he always refused."[132]

Gabe soon learned that Topp intended to marry Elliott. On January 1, 1916, she quietly followed him to a liquor store at West Seventh Street in Los Angeles. Dressed to the nines and carrying a hand muff, Gabe came up behind her lover turned thief and said quietly, "Hello, Leonard."[133] When Topp turned around, Gabe fired a gun she had hidden in the muff, hitting him in the chest.

Liquor store owner John Donohue later testified that he was kneeling behind the counter when he heard Topp come in and call out, "Is anyone here?" Next, Donohue said, he heard a "peculiar" noise, which must have been the gunshot. The bullet had nicked Topp's heart, but he was not yet dead. Donohue said that when he stood up and looked over the counter, he

> saw a woman lying on her back on the floor and Topp on his knees beside her. He had his hands around either her throat or the lower part of her head and was beating her head up and down on the floor. I said, "Shame on you, what are you doing?" Then he got up and started toward me. After a step or two he stopped, stood still a moment and then fell dead on the floor. The woman was so quiet I thought she was dead, but at first I did not think the man was.[134]

Just at that moment, Mr. and Mrs. Ed Shaffer walked into the store to pick up items they had purchased earlier. They, too, later testified about the scene. Others later claimed that after Topp fell, Gabe "also attempted her own destruction," but when police arrived, she was still unconscious on the floor. Later, at the local hospital, Gabe told officers "she did it because he beat her."[135]

Police found the gun in Gabe's hand muff with one cartridge fired. Upon her release from the hospital, she was arrested and taken to the city jail,

where she told officers, "For two years and a half Topp has made me believe he would marry me. I trusted him and believed him. Then, one day, I learned he intended to leave Prescott. I followed him to Los Angeles…I learned just a day or two ago that he was to marry the woman I saw him with." Gabe apparently felt her explanation was enough, for she "refused to say another word and turned from the door of her cell. She absolutely refused to tell where her people lived, or give any other information about herself, except that she was 18 and came [to Los Angeles] from Prescott."[136]

In the days following, Gabe, who very well may have suffered a concussion at Topp's hands, remained in a daze. "Dead Lover's Name Is Constantly on Her Lips," read the headline in the January 13 issue of the *Prescott Journal Miner*. The article went on to say that Gabe had no memory of the shooting. "Great sobs rack her form as she recalls his desertion, and she moans pitifully for his return," the paper reported.[137]

Topp's friends were sad to hear news of his death, "although it was learned this fate to overtake him was not unexpected." Indeed, Gabe had told others that "she would never submit to him abandoning her" and threatened to kill him or herself if he did so. Topp, on the other hand, had informed others of "his desire to get rid of the woman."[138]

As the lurid story hit newspapers throughout California and Arizona, Hollywood-hungry ghouls clamored for news about the murderess and the ensuing trial. In their rush, journalists misspelled Gabe's last name as "Dardley" and "Darley." A sympathetic shadow was soon cast over Gabe, and Earl Rogers, a prominent Los Angeles attorney, even agreed to take her case. Gabe couldn't pay him, but a woman known as a former prostitute visited Rogers's office the day before the trial. The mysterious femme gave Rogers a cigar box containing $3,000 worth of gems to pay for Gabe's defense and left without giving her name.

On the stand, an eager, all-male jury lent an equally sympathetic ear as Gabe told her tale. Her defense seemed cliché, a knock-off of so many other harlots who had slugged, shot or killed their men in the past. "I killed him because I loved him," Gabe said. She also claimed Topp left her after she became ill, although details of the "illness" were never explained. "I loved him," she said, "and for a while we were happy. He was my master. I was content to do anything he ordered me to do, just so he would reward me by saying he loved me."[139]

Gabe also continued to claim that she remembered nothing of the shooting, saying only, "Oh I loved him too much. I would never have been here today, if I had not loved him so."[140] She also appeared most apathetic

about the outcome of her trial, but her sympathizers were not. Courtroom spectators included a number of prominent society women, as well as Salvation Army workers and preachers' wives. The jurors were especially moved when Gabe's friend from Prescott, a striking blonde named Pearl Valley, testified that Topp's favorite pastime was to "scuff the toes of his boots against" Gabe.[141]

Earl Rogers's daughter, Adela Rogers–St. Johns, was just a young newspaper reporter at the time. She, too, took up the cause for Gabe, covering the trial extensively for the *Los Angeles Herald*. In the end, it took the jury just ten minutes to acquit Gabe of murder. Afterward, jury foreman Peter Amestoy spoke for the group, telling reporters, "She had righted a wrong that had been done to her." Rogers–St. Johns chimed in, too, concluding that the jury "understood that with men like Leonard, 'homicide was not only justifiable, but obligatory.'"[142]

Upon Gabe's acquittal, the *Prescott Weekly Journal Miner* reported the story on the front page, declaring, "Italian Beauty Acquitted of Murder." Gabe, according to the paper, "had been the center of admiration since shooting down the man rather than the object of scorn, by even those who would enforce the law with a disregard for sentiment."[143] Back in California, famed soprano Ellen Beach Yaw spirited Gabe away to her own expansive estate for some rest and recuperation. While there, Gabe promised reporters, "From this moment on, I shall live so that good women will not draw aside their skirts when they pass by me."[144]

Gabe tried to make good on her promise by marrying Bernard S. Melvin. By 1917, the couple was living in Calexico, California, when an unemployed Melvin registered for the draft. He served about a year at Camp Kearney before being discharged due to a thyroid condition and heart troubles. The January 1920 census found the couple, along with Melvin's mother and sister, living on a farm outside Burbank, California. In the interest of being discreet about her past, Gabe told the census taker that she and her parents had all been born in Arizona.

Farm life must have been terribly dull to Gabe. By late 1920, she was back in Prescott and operating out of the Gem Hotel at 130 South Montezuma. Two years later, she moved again, this time to the Mason Hotel at 150½ South Montezuma. Melvin, meanwhile, merely followed suit behind the other abusive men in Gabe's life. In December 1922, Prescott's *Weekly Journal Miner* reported that Melvin had been "charged with having robbed his wife, Mrs. Gabrielle Darly [*sic*], of $2,000 at the point of a revolver, and of having cashed her check for that amount here and gone to Los Angeles

The back of the Gem Rooms at 130 Montezuma Street as they appear today. *Jan MacKell Collins.*

with the proceeds." Gabe's complaint was vindicated; the paper reported that a warrant had been issued, and Deputy Sheriff Bill Fitzgerald was on his way to Los Angeles to bring Melvin back to Prescott for trial. It also was noted that the previous week, Gabe had filed for divorce.[145]

Melvin played his marriage to the one-time "murderess" to the hilt, giving an interview to the *Los Angeles Times* while he was in jail. "Gabriell called herself the plaything of men when she was on trial for killing Topp," he sneered from his jail cell. "She still is, but she makes them pay. She's wealthy and has thousands in the bank. I didn't steal that money from her. She gave it to me." Then, in a ploy for sympathy, he added, "We loved each other once, but we're through now, and she hates me. She hated Topp and she killed him. I'm in jail. The man pays, I guess."[146]

Melvin did indeed pay, serving time for his crime.[147] Gabe remained in Prescott, hooking up next with soda pop seller Everett L. "Al" Fretz around 1925. At that early date, Fretz lived at Gabe's Mason Hotel, but Gabe continued using her last married name of Melvin. Fretz eventually married Gabe but relocated to California.

Gabe was still the proprietress of the Mason Hotel in November 1925, when she and one of her girls went to the Elks Theater in downtown Prescott to watch *The Red Kimona*. The film was the third in a series of "social consciousness" movies directed by Dorothy Davenport Reid, whose late husband, Wallace Reid, had been a big movie actor and producer. Actress Priscilla Bonner played the hapless victim—from New Orleans, in the movie's version—who escapes an abusive family and becomes engaged to a man who secretly intends to force her into prostitution. From there, the storyline evolves into Gabe's real life escapades as her character is jilted, follows her man to Los Angeles and guns him down.

The screenplay was in fact based on the writings of Adela Rogers–St. Johns, the same young reporter who covered Gabe's trial following Leonard Topp's death. It's possible that Gabe already knew this latest production was about her since her name was used on both posters and flyers advertising the film. In fact, handbills, "in screaming red ink," were being handed out all over downtown reading, "Gabrielle Darcy [*sic*] is lured to New Orleans."[148] Either way, the madam was surely gasping for air as she watched her life unfold on the screen.

The storyline did deviate from her own experiences, with the heroine eventually finding love and fortune. But the fact that the plot focused on Topp's killing and used Gabe's name must have been devastating to her. There is little doubt that as she left the theater, she was already planning a lawsuit. Reid and even Rogers–St. Johns were attempting to point out the evils of white slavery, prostitution and addiction, but they had neglected to obtain permission from the very women who inspired them to do so. The point was made when Gabe filed her suit in June 1928 against Reid and All-Star Features Distributors Inc. for invasion of privacy.

Posters advertising *The Red Kimono* daringly used Gabe's name and were widely distributed. *Jan MacKell Collins.*

Newspapers across America covered the sensational lawsuit between Gabe and Dorothy Reid. *Courtesy of the Gabriell Wiley estate.*

Gabe's suit claimed the film portrayed her "as a woman of lewd characteristic, a prostitute and a murderess." She also requested damages in the amount of $50,000. Such a lawsuit was quite novel, even for Hollywood, at the time. The *New York Times* ran a story about it, and writers who had covered Topp's killing were happy to pick up where they left off.

The suit took years to settle, as Reid's attorney, Walter Burke, tried to explain that the film was meant to be educational and advertised "only a true story of what was shown by the records of the Los Angeles Superior Court, the facts of which had already been published."[149] Gabe, meanwhile, made the best of her circumstances as a somewhat tainted public figure. By 1929, she had relocated to a new bordello, a former boardinghouse called the Rex Arms, at 302 West Gurley Street. She appeared in public less often, but those who saw her on the street could not help but admire her flashy wardrobe. Paul Toci, a longtime Prescott resident, described Gabe as "a beautiful woman. Unless you knew she was from the whorehouse, you'd never guess it."[150]

Even under pressure, Gabe became an astute businesswoman. It was said that she amassed the largest diamond collection in Arizona, and when she raised her rates from two to three dollars, nobody blinked an eye. "She was one of the first whores to do it, and she got it, too," said Leonard Black,

The Rex Arms, seen here from the back, was already discreetly functioning as a brothel when Gabe took it over. *Sharlot Hall Museum, bub8231pa.*

one of Gabe's former customers. Black also remembered other things about Gabe and her girls: "At the Rex Arms you could stay all night for $12. They asked for $15, but they'd take $12. But you didn't get to know Gabe too well. It was just business with her, and it was business with me, too. I tried her a few times and she was like the rest."[151]

Frank Polk of Mayer remembered Gabe, too. "Yeah, in those days she was quite a high-toned gal," he later recalled. "She bootlegged and had some slot machines at her place. We'd come to town after roundup, and first thing we'd do is hit the Palace Bar and get a bath in back, then we'd get ourselves a new shirt, and go see Gabe. Everybody went to Gabe's." Once, Polk was late in joining his fellow cowboys. By the time he got to Gabe's, the other girls were all taken. Upon seeing Polk without a girl, Gabe said, "Come on, Frank. I'll screw you."[152]

Gabe also was unusually good to her girls. Those who knew her remembered she put several of her employees through business college and was in the habit of treating them to a nightcap at the Palace after closing up the Rex for the night. Gabe's girls wore eveningwear, but the madam dressed more businesslike. Mary Swartz, whose husband, Bob, managed the Palace and served her girls, remembered Gabe well. "She was plump, pretty, and usually dressed in suits," Mary said. "But she had a different shade of red hair every time. Those dye jobs didn't cut it in those days."[153]

WILD WOMEN OF PRESCOTT, ARIZONA

On a 1930s outing to Granite Dells, Gabe had a photographer take several pictures of herself (left) and each of her girls (right). The pictures could have been used to advertise Gabe's bordello. *Courtesy of the Gabriell Wiley estate.*

Locals might have known that Gabe was running a brothel at the Rex, but the census taker was no wiser in 1930. Gabe's lodgers included twenty-eight-year-old Paul Remington, who worked as an electrician, and twenty-four-year-old Dean Howard, who was an automobile laborer. Two women, Margaret Dean and Sylvia Blood, each listed her age as thirty-two years old and were employed as a seamstress and dressmaker, respectively. Gabe herself said she was born in Arizona; she also said that she was Mrs. Gabrielle [*sic*] Fretz and that she had been married for fourteen years. At the time of the census, Al Fretz was in fact living in Los Angeles and renting a room from moving picture actor Philip H. Bloom and his wife.

Gabe and her "lodgers" may have been masking their identities because of the suit against Dorothy Reid, which was finally settled in February 1931. California's court of appeals found that in the years following Topp's killing, Gabe had indeed

abandoned her life of shame and became entirely rehabilitated; that during the year 1919, she married Bernard Melvin and commenced the duties of caring for their home, and thereafter at all times lived an exemplary, virtuous, honorable and righteous life; that she assumed a place in respectable society and made many friends who were not aware of the incidents of her earlier life.[154]

Gabe had also made sure Al Fretz was back in town, working as a respectable barber.

The fact that Gabe had reentered her life as a prostitute had little bearing on the court's acknowledgment that with the release of *The Red Kimona*, Gabe's many friends "learned for the first time of the unsavory incidents of her early life. This caused them to scorn and abandon her and exposed her to obloquy, contempt, and ridicule, causing her grievous mental and physical suffering to her damage in the sum of fifty thousand dollars." For the first time in the United States, a person's right to privacy was officially made into a law because of Gabe's lawsuit. "We find…that the fundamental law of our state contains provisions which, we believe, permit us to recognize the right to pursue and obtain safety and happiness without improper infringements thereon by others," read the court documents.[155]

Reid and company appealed the decision but were denied by both the District Court of Appeals and the Supreme Court. Gabe won not only her right to privacy but also the $50,000. More importantly, she was the first person to make lawmakers see the value in privacy laws. Dorothy Reid lost her house and a lot of money, filing for bankruptcy in 1933. She did go on to write and direct more films before her death in 1977.

A striking portrait of Gabe, taken in her prime as Prescott's leading madam. *Courtesy of the Gabriell Wiley estate.*

> **"Gabe's Place"**
>
> **Belmont Rooms**
>
> 208½ So. Montezuma Phone 540

Gabe's business card from the Belmont Rooms. *Courtesy of the Gabriell Wiley estate.*

Gabe and Al remained at the Rex, where Al ran the Rex Club on the bottom floor of Gabe's brothel. By 1935, Gabe had moved from the Rex Arms to the more visible Belmont Rooms on Montezuma Street. She was still the reigning madam there when Al Fretz died on September 24, 1935. He was a patient of the Arizona State Hospital in Phoenix at the time, succumbing to "general paralysis of the insane." He may have only recently entered there, as his last physician reported first seeing him on August 29.[156]

According to some writers, Fretz's symptoms suggested he had been poisoned, and as usual, fingers pointed at Gabe. But in fact, there was no evidence of foul play. The widow even received a letter of sympathy from the Elks Lodge in Los Angeles, where her husband had been a member. Within a year of his death, Gabe also penned a letter to her attorney, R.B. Westervelt, stating that should she die, she wanted to be cremated and her ashes placed in an urn and buried with Al Fretz. From all appearances, Fretz remained Gabe's favorite husband of all she had married.

At least, for a little while.

On July 31, 1937, Gabe married George Henry Wiley, a former rancher, miner and liquor store dealer. The couple was united at the Palace Saloon in Prescott, with the ceremony officiated by Yavapai County judge Gordon Clark, aka "the midget minister." The newlyweds next moved to Salome and set up a lucrative business that included a liquor store, the Free Lunch Café, an auto court and a gas station. Under her old nickname, "Dollie," Gabe also ran cribs out in back of her house. The cribs were described as "shacks" by writer Leo Banks, each with "a single room spacious enough for a man to pull off his boots, a mattress on the floor and a bathroom, nothing more."[157]

The Wiley house was of solid construction, with five spacious rooms and a front porch shaded by pecan trees. The back room served as a lounge with a couch for male customers.

At the time of the 1940 census, George was in Salome, but Gabe was in Prescott. She was back in Salome by September 1941, when George got into a heated argument with one of her girls at the café. The young woman, Mae Moore Grisson, had formerly worked for Gabe at the Rex Arms and wanted the Wileys to pay for the storage of some furs she had left in Prescott. During the argument, George allegedly lunged at Mae, who fell off of her stool and hit her head on a water cooler. The unconscious woman was taken to the hospital in Wickenburg. She was still there two weeks later when she suffered a coughing fit. A blood vessel in her brain burst, and she died.

Although he never touched her, George was charged with causing Mae's death. Gabe pawned a diamond ring in Wickenburg and gathered the $3,000 needed to bail him out of jail. The trial was set for some months later. On January 10, 1942, however, George suddenly succumbed to the effects of drinking rat poison in a glass of milk. A friend of the Wileys, John Percy Brusco, found George's body in a guesthouse on the property.[158]

George's death was ruled a suicide, but as usual, Gabe was suspected of having something to do with his death. Also as usual, nothing ever came of the whispered accusation. Afterward, Gabe pretty much retired from the prostitution industry, but she continued dying her graying hair red and wearing nice clothes and beautiful jewelry. She also attended church and joined the Ladies Club in Salome. Club member Dorothy Matthews later remembered that Gabe never discussed her past with ladies of the club, focusing instead on upcoming events and fundraisers.

Gabe's further attempts at the respectability she had yearned for were evidenced by her donations to the Episcopal Church and her annual Thanksgiving feasts, which were attended by both her former employees and customers.[159] Gabe eventually became a driving force in Salome in many ways. She dabbled extensively in local politics, often writing to government officials on behalf of local citizens.

As the years passed, Gabe began suffering from Parkinson's disease and fell frequently. Prescott native Elisabeth Ruffner often accompanied her father-in-law, Lester Ruffner, as he delivered newspapers to Salome. Gabe was a customer, receiving papers at the motel. "She was a very old woman then, in a housedress and slippers," said Ruffner.[160]

In 1948, Gilbert Layral, Gabe's nephew from France, immigrated to America and worked for her briefly in Salome. Layral later said that one of

WILD WOMEN OF PRESCOTT, ARIZONA

Seven-year-old John Brusco poses with his mother (with arm around John), Gabe (in apron) and friends in Salome. *Courtesy of the Gabriell Wiley estate.*

his aunt's supposed "best friends" told him that Gabe "had killed every man she had." But he also said the rumor had nothing to do with him deciding to move to California. "No, I left Salome because I didn't like it there," he said in 1999. "I didn't like taking care of her chickens."[161]

Shortly after Layral left Salome, Gabe took another spill. Ten-year-old John Brusco Jr. was with her at the time and helped her off the ground. "My parents befriended her because they took to people with heart," said Brusco, "and Dollie had a good heart. The rest of the town sort of shunned her, and our family was probably the first to treat her right." The Bruscos' friendship with Dollie lasted for the rest of her life. "I loved her dearly, she was like a grandma to me," Brusco said. In turn, young Brusco became the grandson Gabe never had. In 1948, she changed her will, designating John as her sole heir.[162]

During the last years of her life, Gabe's love for the people of Salome never faltered. In August 1962, Gabe's neighbor Bill Gabbard was arrested for shooting another man during an argument. Almost immediately, Gabe showed up at the Gabbard home and offered to pay for a defense lawyer. "I went out to the front," Gabbard remembered, "and there was my wife and Dollie standing there. Dollie didn't say nothin', and she was bent over and shakin', but she was smiling that little smile she always had." Later, Gabbard was found not guilty. "I tell you, if it wasn't for her, I'd still be in that jail," he said. "I think about her a lot. She sure was a fine lady."[163]

Just before Christmas 1962, Gabe fell again. She was taken to the hospital in Wickenburg, where she summoned her old friend Lester Ruffner in Prescott. Upon his arrival, Ruffner helped Gabe plan for a public, Episcopalian funeral at Ruffner's Funeral Chapel at a cost of $1,000. Her ashes were to be interred beside the grave of Al Fretz at Mountain View Cemetery in Prescott.

Gabe died on Christmas Day 1962. Several factors contributed to her death, including "terminal pneumonia," a fractured femur and Parkinson's disease. Perhaps fittingly, her cause of death was labeled an "accident." Her urn was buried on January 18, 1963, next to Fretz, perhaps the only man in her life she was ever able to trust. Today, no marker identifies her grave.

Chapter 9
THE LAW IS THE LAW

Unlike in so many other cities across the West, Prescott's red-light ladies enjoyed unheralded freedom. Early on, citizens made their position clear on the world's oldest profession. For decades, even as Arizona Territory increasingly imposed laws, regulations and fines on the prostitution industry, Prescott officials always found a way to skirt the issue.

One of the first people to fight prostitution in Prescott was Mrs. Caroline Cedarholm, missionary, who arrived in 1870. Cedarholm advertised herself as a nurse and physician, but her true purpose was to confront and reform drunken miners and prostitutes. She immediately set about convincing twelve soldiers to take the "pledge" to reform. In the red-light district, Cedarholm also spent time nursing and doing the wash for the girls in hopes of convincing them to pursue a better life. But the residents of Prescott were less than happy to see her. The *Arizona Miner* newspaper especially seemed to take great joy in criticizing and teasing her.

In May 1871, her hopes dashed for establishing a church and her endeavors largely unsuccessful, Cedarholm and her associate, a Miss Garrison, finally gave up and left town. The *Miner* was only too happy to see them off. "After a long and earnest effort on the part of these ladies to raise Prescott away up toward heaven," the paper explained, "they became disgusted at their ill success and our want of godliness as a people, and hence departed for the sunny south, in quest of more tractable disciples. May your portion be a grand success and a prolonged absence from Prescott, ladies."[164]

Aside from Cedarholm's efforts, Prescott's only real stab at temperance was when the Pioneer Temperate Society was formed in 1873. Even then, it was agreed that members "may drink wine and malt liquors but shall abstain from distilled spirits." An article about the new club noted that just a year before, a similar endeavor by the Order of the Good Templars failed miserably when four officers were found intoxicated prior to a meeting. By that evening, "most of the high pirates went on a general bender."[165]

Even Arizona Territory's initial approach to prostitution was mild at best. The first state statute to appear in 1887 merely decreed that

> *every person who keeps any disorderly house, or any house of ill fame for the purposes of assignation or prostitution, or any house of public resort by which the peace, comfort, or deceny [sic] of the immediate neighborhood is habitually disturbed, or who keeps any inn in a disorderly manner, is guilty of a misdemeanor.*[166]

In other words, according to the law, keep it down and don't disturb the neighbors or you might get ticket.

In 1891, the Arizona Territory Legislative Assembly took its somewhat permissible law against prostitution one step further. This time, a new law was enacted against bawdyhouses being located in proximity to schools, public buildings and any other place innocent or respectable people might occupy. This first issue was addressed right off the bat in Section 1:

> *Every person who keeps, or willfully resides in any room or house of ill fame or ill repute resorted to for the purpose of prostitution or assignment, within a certain distance from any County Court House, Public School, City Hall, or any other public building of any nature in this Territory, such distance to be established by the County Board of Supervisors in all towns, villages, or mining camps not incorporated and by the Mayor and Common Council, of all incorporated cities or towns, shall be guilty of a misdemeanor.*[167]

More laws prohibited renting buildings for the purpose of prostitution "within the limits as established by the Mayors and councils of incorporated town or cities and by the Board of Supervisors," and failing to vacate after being notified to do so in writing was also a misdemeanor. The new laws also established fines for violations, to the tune of $25 up to $100 and/or twenty five to one hundred days in jail.[168]

An early postcard makes light of official "brothel inspectors," policemen hired to maintain order within houses of prostitution. *Jan MacKell Collins*.

An early engraving illustrates how prostitutes solicited customers. *Jan MacKell Collins.*

Prescott had already abided by the new statutes by establishing an official red-light district on South Granite Street. Soiled doves, however, were also still free to solicit and ply their trade along Whiskey Row's numerous saloons and their upper floors. Territorial officials clamped down a little harder in 1893, resulting in some new city ordinances as of September.

Wild Women of Prescott, Arizona

Section 1 of City Ordinance No. 71 decreed that females could no longer

> *enter in, or loiter in, or drink beer, wine, ardent, malt, or fermented liquor, or intoxicating spirits of any kind whatever, in any saloon, clubroom, clubhouse, gambling room, or gambling house, or any room, house or place used in connection therewith, or used as any part thereof either directly or indirectly, in the said city of Prescott.*

Sections 2 and 3 prohibited saloonkeepers, or anyone else for that matter, from allowing women to violate Section 1. Finally, Section 4 decreed any violations of these laws a misdemeanor, punishable by a fine ranging from the usual $25 to $100. It is interesting to note that one councilman, a man named Marks, voted no.[169]

The city seemed content with its new ordinances, even as Arizona Territory's legal age of consent was raised from age fourteen to eighteen beginning in 1893. All was fairly quiet until July 1900, when Whiskey Row and the red-light district burned to the ground. Whether the city officials thought their wanton women would just go away is unknown. What is known is that by November, lots of ladies had rebuilt in Block 13, their old stomping grounds on the back half of Whiskey Row. A new ordinance quickly designated the new red-light district as Block 19, one block south of the old one, between Goodwin and Carleton Streets. No brothels were allowed to open off the alley, and all entrances were to be well lit at night. Anyone operating a brothel, hiring prostitutes or working outside the restricted area would be fined $100.

It was too late; most of the town's scarlet women had already set up shop by the time the ordinance was put into action. This time, however, the brothel owners were careful to construct neat little cribs, which made more efficient use of space and presented a more tidy appearance. The city may have been dismayed that its red-light district was reconstructed, but it also knew that the fines and taxes the girls paid were important to the city's economy. So, even though the new district violated the new ordinance, city officials politely looked the other way.

The prostitutes' disregard for the new city ordinance echoed throughout the state. In 1901, the Arizona Revised Statutes included new laws against enticing females to enter houses of prostitution and also required parental consent for girls to become prostitutes before the age of eighteen. For the first time, rape also became a chargeable offense, with a sentence from five years to life for violators. There also were additional laws against school

officials having intercourse with female students and coercing a girl under eighteen into sexual intercourse under the promise to marry. And it was declared a misdemeanor for anyone to live "in a state of open and notorious cohabitation and adultery."[170]

The new laws also covered the incorporation of any new cities in the territory, prohibiting them from allowing "houses or places of ill fame, bawdyhouses, and houses of assignation within the limits of the city." Furthermore, new cities were given the power "to impose fines and penalties upon any person or persons for keeping, remaining at or frequenting the same and to compel any person to testify in all cases touching the same: Provided, That such witnesses shall not be punished for anything disclosed in such testimony."[171]

Leniency against prostitution in Prescott and other towns prompted such lighthearted postcards as this. Jan MacKell Collins.

In addition to the new laws, the 1891 statutes were updated to establish that brothels within 250 yards of a public building or 400 yards of a school were in violation. The update immediately endangered the Granite Street girls, whose well-established bordellos were already in proximity to the Yavapai County Courthouse across from Whiskey Row. Prescott newspapers took a satirical slant to this newest law:

> *We heard a man say, the other day, that the 250 yard limit law was a blow against the protection of society, which caused us to reflect that the supposed menace to society who became unsafe within the short distance of 250 yards must be constructed on a rather spontaneous plan.*[172]

To the red-light ladies, staying away from a school seemed reasonable enough; relocating to appease occupants of a public building, however, just seemed silly. The cribs and bordellos remained in place, but opponents of the red-light district pushed the issue to a grand jury trial soon after the law was passed. The newspaper heartily rooted for the men to follow Judge Sloan's lead as he "read extracts from the revised laws of Arizona bearing on the social evil and the 250 yard limit, and emphasized the necessity for the enforcement of such law."[173]

Both the newspaper and Prescott's moral majority were disappointed when the grand jury returned its verdict:

> *The grand jury have given earnest consideration to that portion of the charge of the court relating to houses of ill fame and lewd women, conducting their places within certain distances from public buildings, with a view to perform their duties in the premises for the best interests of the county, and have reached the conclusion that the interests of the taxpayers and law abiding people of the county demand that no action be taken by the grand jury. The regulation or suppression of the so-called "social evil" has been a question that has vexed every civilized community since civilization existed. Attempts to entirely do away with this evil have always failed and must always fail, so long as human nature remains as it is.*[174]

A slew of retorts to the grand jury's decision were immediately published in local papers. "The typewriter which knocked off that report to Judge Sloan on the social evil law is said to wear as a dust cover a red mother hubbard without a belly band," sneered the papers. "The Jury's report sounds more like the production of an attorney paid to defend the practice," accused a reporter from nearby Jerome. "It might not be amiss to call an investigation of the grand jury."[175]

In time, the fuss subsided as officials found more ways to make money from the prostitution industry in their midst. In 1902, the city adopted Ordinance No. 122, which decreed that prostitutes must pay a five-dollar fine each month to the city. Also, Ordinance No. 126 stipulated that the girls had to submit to health exams every ten days and obtain health certificates in order to work.

Harder ordinances continued to be passed as American society began leaning toward doing away with prostitution. On January 23, 1907, Arizona Territory passed all new legislation—an "act to suppress lewdness in saloons"—that banned all women from bars, including singers and

> **C. B. NO. 3.**
>
> # *A N A C T*
>
> **TO SUPPRESS LEWDNESS IN SALOONS.**
>
> January 23, 1907.—Introduced by Mr. Hunt. Read first time, rules suspended, read second time by Title, 200 copies ordered printed, and referred to Committee on Judiciary.
>
> ---
>
> Be it Enacted by the Legislative Assembly of the Territory of Arizona:
>
> 1 Sec. 1. It shall be unlawful for any prostitute, woman of ill fame, or woman of any of the
> 2 classes known as saloon-women, concert singers, saloon singers, sporting women, and dancing
> 3 girls, either for hire or otherwise, to sing, to recite, to dance, to play on any musical instrument,
> 4 to give any theatrical or other exhibition, to drink, to serve drinks or any form of refresh-
> 5 ments or viands, or to solicit for the purchase or sale thereof, to engage in or to take part in
> 6 any game of chance or amusement or to loiter in any saloon or in any room or apartment ad-

Prescott's ordinance "to suppress lewdness" did little to quell the red-light ladies working along Whiskey Row. *Jan MacKell Collins.*

performers.[176] This latest law was most disappointing to the saloon singers and their fans. "Citizens would sit on the benches across from Whiskey Row," recalled Prescott poet and historian Gail Gardner, "citizens of both sexes, and listen to the concert these little singers would give, people who would never dream of entering the swinging doors of the saloon, but they sat over in the Plaza and enjoyed the concert."[177]

It is notable that many female saloon performers of the West were not prostitutes. Those who did supplement their incomes by entertaining men, however, caused the whole lot to be regarded as bad girls. No matter their

innocence, the 1907 law lumped the "concert singers, saloon singers" and "dancing girls" right in with the prostitutes, women of ill fame, women "of any of the classes known as saloon-women" and "sporting women." All of them were forbidden from singing, reciting, dancing, playing musical instruments or giving any "theatrical or other exhibition."[178]

As usual, the new law was accompanied by the reiteration that women also were not allowed to enter saloons, drink, serve drinks, gamble or loiter in any saloon or attached apartment or rooms. The law was further updated in March, decreeing that violators would now spend ten days to six months in jail. The territory did, however, repeal the prohibition of gambling.

The shady ladies of Prescott must have regarded all of the new laws with disinterest, for about forty girls still worked in town during 1910. Those who feared the new laws, or wanted to avoid arrest, began working in other parts of town, where they were harder for the law to find. Many of the women

By the time of the 1910 Sanborn Fire Insurance map, many women had moved out of the old restricted district along South Granite Street.

139

had no other choice. Their plights were emphasized by James Oppenheim, who voiced his opinion in the May issue of *American* magazine: "You may try for a time to stop prostitution by closing up houses and arresting women, but if shop-girls are still paid wages on which they cannot live, wherein has the problem been touched."[179]

Oppenheim's editorial did little to extract sympathy from those against prostitution. In June 1912, Reverend H.E. Marshall of the Baptist Church took matters into his own hands, filing a complaint that Prescott's wayward women were indeed operating within 250 feet of city hall and the Yavapai County Courthouse. By law, officers were forced by the complaint to arrest eight bordello owners and twenty-eight prostitutes composing the entire red-light district.

The *Weekly Journal Miner* duly reported on the event and included Reverend Marshall's "Open Letter." In an attempt to justify his actions, the reverend reiterated that the law had not been maintained, adding, "I am not doing this with the intent to cause anyone suffering or sorrow, but the reverse." Marshall concluded his letter with an offer to "assist any girl who may come to Mrs. Marshall or me, to lead a better life."[180]

The reverend's offer fell on deaf ears. On the day of the trial, quite the crowd jammed into the courtroom before Judge Lane as all thirty-six defendants, their attorney R.P. Talbot, city officials and a curious public awaited proceedings. Talbot pleaded "not guilty" on behalf of his clients, and Judge McClean had started assigning court dates when county attorney P.W. O'Sullivan asked to address the court. Certainly, the audience members were on the edge of their seats as the lawyer began to speak.

O'Sullivan began by pointing out that each defendant had paid a monthly fine of five dollars the previous May in accordance with the city ordinance. In fact, O'Sullivan said, the monthly payments had been in force for well over ten years. "In other words," he declared, "the City of Prescott has been regulating houses of ill fame and the inmates thereof…The City has confined said women to a certain district, and they are at all times under police surveillance."[181] Next, O'Sullivan informed the court that Reverend Marshall had already appealed his case to the grand jury the previous April and that the reply was to inform him that the issue was a city matter and not the state's problem. Since the prostitutes already paid monthly fines to the city, he explained, it was illegal to fine them again through the state.

But it was O'Sullivan's closing statement that surely made the record books as one of the most astounding directives ever uttered by a government-appointed lawyer:

Even before it was rebuilt in 1900, the Yavapai County Courthouse always remained in proximity to the red-light district. *Jan MacKell Collins.*

> *Be that as it may, no man or woman, no matter how poor or degraded, will be persecuted or oppressed by Mr. Marshall or any other person, while I have the power to prevent it. I therefore, as County Attorney, respectfully move the court to dismiss all complaints against these women on the charge of being inmates of houses of ill fame.*[182]

Sullivan was so loudly applauded that Judge McLane "was compelled to rap repeatedly for order." Reverend Marshall's retort that the fight was not over fell on deaf ears. The following week, not more than an inch of column space in the newspaper informed the public that all of the cases against Prescott's red-light denizens had been dropped.[183]

If Reverend Marshall realized any victory at all, it was in 1913, when the newly formed State of Arizona enacted another law. This declared that anyone could file a complaint against a brothel, which would officially make it a nuisance and subject to closure. For good measure, another new law prohibited constructing new buildings for prostitution purposes.

In Prescott, it was business as usual. During the divorce proceedings of John and Rosie Waddell in March, Waddell accused his wife of adultery, while she countered that he had committed an "act of cruelty" against her. When Judge Smith discovered that Rosie had in fact been living in the red-light district, he dismissed the case and refused to grant the divorce. He did, however, instruct the sheriff and his deputies "to forthwith arrest any married woman living as a prostitute in Yavapai County."[184]

The judge further admonished the Waddells, declaring that "while incorporated cities do not have the right to determine whether prostitution should be permitted or to be carried on within any city, that has nothing whatever to do with the crime of adultery that is punishable under the laws of the state." The couple agreed to behave, but within hours of the proceedings, Rosie was discovered back in the red-light district. She was arrested again and, upon her release, was last known to be headed toward Spokane, Washington. In the wake of her departure, John Waddell filed for divorce once more and probably got it.[185]

On August 16, for the first time, the Prescott City Council passed Ordinance No. 706, recognizing prostitution as a misdemeanor punishable by a fine. The fines and imprisonment remained the same as with most of the city's prostitution ordinances, but the city also added Lots 10 through 12 to the red-light district in Block 13. Also included was Lyda's dance hall, which actually sat right in the middle of Goodwin Street at Granite. By doing so, officials all but declared that the red-light district could continue operating unmolested. "The city fathers are not inclined," reported the *Journal Miner*, "to consider any possible action to enforce the new and stringent 'red-light' measure which goes into effect at midnight, by the county or private individuals."[186]

The newspaper also pointed out a few other things, including the fact that the new laws were simply a reiteration of the old laws with more stringent penalties, and that most of the houses of ill repute on Goodwin and Granite Streets had violated the distance laws all along. "The city has paid no attention to this fact in the past," the paper reported. "Neither have the city council, nor anyone else." The paper went on to suggest that the likelihood of punishment against lawbreakers was slim to none, unless someone filed a formal complaint. Furthermore, readers found, the clerk of the council and assessor planned to "visit with every property owner in that vicinity relative to his desire to permit his property to be included in that district."[187]

Unfortunately, even Prescott officials could not keep modern laws from encroaching on its beloved red-light district. Statewide prohibition in Arizona was passed on November 3, 1914, and slated to take effect on January 1,

WILD WOMEN OF PRESCOTT, ARIZONA

Even with prohibition in Arizona in 1915 and nationwide in 1918, many diehard saloon owners refused to give up the fight. *Jan MacKell Collins.*

1915. In November 1916, the "bonedry" amendment also prohibited importation of liquor.[188] Prescott's red-light district held steady until 1917, when all brothel owners and their prostitutes received official military orders from Fort Whipple to close.

For decades, military bases across the West had suffered at the hands of prostitution near their forts. Soldiers were contracting social diseases, going AWOL, returning to duty drunk and fighting. Fort Whipple's efforts were only a preview to 1918, when the United States Army surgeon general closed all houses of prostitution across America in an attempt to prevent the spread of disease. Accordingly, the State of Arizona issued a final law ordering all brothels to close by March 1. "Troops in Arizona are given the completest [*sic*] possible protection from venereal diseases," the newspapers explained. "Houses of ill-fame, in the opinion of the Board of Health, tend to spread disease. Not only it is made unlawful

to operate them, but any official refusing to suppress them may also be punished by the board."[189]

Even before the new law could take effect, Lieutenant Paul Popenoe of the army's surgeon general staff arrived suddenly, on February 22, at the office of Prescott police chief Tom McMahon. With McMahon in tow, Popenoe next made a beeline to the red-light district and began knocking on doors. Each occupant who answered was told to clear out no later than the night of February 24 and that her career as a prostitute in Prescott was over. Now. Period. "Within 15 minutes after the word had spread through the 'line' that its days were numbered, the majority of the women had begun the work of packing up their belongings," the local newspaper reported. "Lace curtains were hastily pulled down from the windows, flimsy lingerie was stowed away in trunks, and phonographs and other large pieces of furniture were being crated up for shipment."[190]

Most of the district's forty female occupants, according to the paper, expressed plans to move on to Nevada or Los Angeles. Whether they really traveled that far is unknown, but it is a fact that authorities still had to contend with the state's two largest districts at Jerome and Superior, as well as in Phoenix and also a number of mining camps scattered throughout the territory. And there was still at least one serious downfall to the military's plan: physicians were now forbidden from issuing health certificates to working girls. To those women who stubbornly stayed in the profession, their hesitance to seek medical care for sexually transmitted diseases for fear of being arrested was a virtual death sentence.

If the moral majority thought the new laws would obliterate their red-light district once and for all, they were dead wrong. Prostitution came to the limelight again when soldiers killed a patron at Nellie Stewart's brothel on January 3, 1919. The murderers were from Fort Whipple. A short time later, the United States Army stepped in again, proclaiming that "immoral women are too free to ply their trade" and strongly implying that prostitution and bootlegging had no place in Prescott.[191]

Indeed, by the end of World War I, Prescott's prostitution industry was back in bloom. Like so many other places in the West, the ladies just stayed scattered to avoid the law, operating in former boardinghouses, above the former saloons along Whiskey Row and in certain downtown hotels. For nearly ten years, their businesses stayed under the radar, the exception being the occasional news item when the law was forced to intervene.

By 1928, it was generally known and accepted that women continued to sell sex. In May, officers raided the Gent Rooming House and arrested madam

Wild Women of Prescott, Arizona

With nationwide Prohibition and crackdowns on prostitution, bootleggers and prostitutes alike used tunnels running under the buildings along Montezuma Street. *Jan MacKell Collins.*

Irene Brown and her employee Nelly Smith. "Vice Conditions on South Granite Exposed," read one headline.[192] Irene, who was accused of running a bordello, pleaded not guilty. Nelly, however, admitted to her crime.

For many more years, the city of Prescott quietly acquiesced to the prostitution industry still operating in town. During the 1940s, the city of Prescott's health officer was Dr. Clarence E. Yount, who operated in the Masonic Temple Building on North Cortez Street. "He shared the office

A 1926 poem pays tribute to the bawdy women of the West. Jan MacKell Collins.

with his daughter-in-law, Dr. Florence Yount," said Prescott native Elisabeth Ruffner. "He and only one other physician were in practice in these early years of World War II."[193]

At the time, Ruffner worked for the physicians as a lab technician. She remembered that businessman Frank Tutt, who later became mayor of

Wild Women of Prescott, Arizona

Even with prostitution officially outlawed, certain women, such as this employee of Madam Gabe Wiley, remained in town. *Courtesy of the Gabriell Wiley estate.*

Prescott, was in the lumber business with Harold Crain, whose wife was a madam at Rex Arms. Ruffner remembered that practicing prostitutes were still required to visit Yount's office for monthly health exams. "Mrs. Crain often accompanied the women, holding her little white poodle, very properly dressed as a business woman," she remembered.[194]

Once, according to Ruffner, one of the women from the Rex was found to have venereal disease. Dr. Yount immediately quarantined the entire brothel, instructing Ruffner to go put a sign to that effect on the front door. "In the absence of such a notice for the current quarantine," Ruffner explained, "I was dispatched to locate an appropriate notice, and finally found one at a lumber yard: 'CLOSED FOR REPAIRS.'"[195]

Another of Gabe Wiley's lovely ladies. This portrait dates to about the 1930s. *Courtesy of the Gabriell Wiley estate.*

Chapter 10
A LOOK BACK

It is difficult to pinpoint a clear cut-off date to Prescott's notorious prostitution history, mostly because the industry survived in some form or another long after military forces closed down brothels throughout the state. It seems as though everyone, from historians and writers to old-timers, claims that prostitution flourished in town as recently as the 1960s. By then, however, the industry as it was known was a far cry from the days of Granite Street's lively bawdyhouse district.

With reference to the old "Wild West" prostitution that history buffs enjoy studying, Prescott's red-light district began its slow decline in about 1913. As the remaining girls of the demimonde drifted elsewhere, the former cribs and bordellos along South Granite Street remained for a time as small "flophouse-type" apartments where the city's poor could find shelter. One of these was Lot Smith, a ninety-five-year-old widower who died at 224 South Granite in 1915. Smith, most unfortunately, represented several elderly citizens who found themselves destitute with no better place to live.

Also remaining on South Granite was a handful of former shady ladies who had nowhere else to go. They included Carrie Neal, who had lived in the red-light district since at least 1900, and another former working girl, Maude Brooks. Both women remained in the 200 Block of South Granite until their deaths. When Carrie Neal died in 1918, it was Maude who reported her death.

By 1923, the former bordellos of Granite Street were quite diversified. Jack Dye's billiard rooms now operated at the once celebrated Union

By 1924, the Sanborn map shows that most of Prescott's red-light district had evolved into pool halls, hotels and tenements.

Saloon, while a former bordello now operated as the Lafayette Rooms and Emery Bosley Billiards. Several Mexican residents, as well as Chinese, were living in what was now Prescott's poorest neighborhood.[196] Although South Granite Street was occasionally inhabited by a mere sprinkling of shady ladies, most of the residents are largely remembered only by their

documented deaths: eighty-year-old Lee Johnson in 1923, forty-four-year-old Ophelia Webb in 1924, Maria Castro in 1925 and so on.

By 1926, the site of Annie Hamilton's old place was now known as the Palace Parking Station and used by the former Palace Saloon on Whiskey Row.[197] Five years later, much of the old red-light district was also used for parking as the old cribs and brothels slowly fell into disuse and were torn down. One of the last working girls from the old days, Maude Brooks, died on November 2, 1932, at 216 South Granite Street. Despite decades of living in Prescott, virtually nothing was known about the "negress" Maude, including her age (guessed to be eighty), her birth date, where she was born or the name of her parents. She was buried in Citizens Cemetery but received no marker.[198]

Ultimately, even the old Union Saloon was torn down in about 1938. A year later, in February 1939, eighty-one-year-old Sam Kee was found dead in the old Joss House. Formerly the proprietor of a "noodle joint" on West Gurley Street, Kee was thought to have died of natural causes.[199] In fact, most of the Chinese residents were leaving town, exiting en masse to greener pastures in California.[200]

Memories of Prescott's bawdier days were briefly brought back to life in 1940, when the notorious "Big Nose Kate" died at the Arizona Pioneers Home. Kate had actually been a resident at the home for nearly a decade, but her death inspired writers and historians from all over to repeat what they knew about this enigmatic and illustrious woman.

Born in 1850 in Hungary as Mary Katharine Harony, Kate was the daughter of a wealthy physician when she came to America at the age of ten. By 1863, her family had settled in the Hungarian neighborhood in Davenport, Iowa. Two years later, both of Kate's parents died within a month of each other. Kate and her siblings first lived with her brother-in-law, Gustav Susemihl, until 1867, when one Otto Smith petitioned to take custody of the children. By then, according to court records, Kate had left home and "cannot be found anywhere because she went, it is said, to parts unknown and hence could not be found anywhere."[201]

Kate's adventures were many in those early years. If everything about her is to be believed, she stowed away on a steamship bound for St. Louis and carried on with ship captain Burlington Fisher, spent a short time at the Ursuline Convent in St. Louis, married Silas Melvin and had a son by him, lost both Melvin and the boy to yellow fever and went to work for St. Louis madam Blanc Tribolet in 1869. When Blanc was killed by a customer, Kate allegedly avenged her death by shooting the man and left St. Louis.

In the summer of 1874, Kate was arrested twice at the sporting house of Sallie and Bessie Earp in Wichita, Kansas. On at least one occasion, she gave her name as Kate Earp, backing up suppositions that she once had a fling with Wyatt Earp. The 1875 Kansas census next found her working at Tom Sherman's dance hall in Dodge City under the name Kate Elder, just a year before Earp and his brother James arrived in town. Around that time, give or take a few years, Kate met John Henry "Doc" Holliday, a dentist who loved gambling more than pulling teeth.

In her later years, Kate recalled her growing fondness for Doc:

> *He was a gentleman in manners to the Ladies and everyone. Being quiet, he never hunted for trouble…He always had a bottle of whiskey but never drank habitually. When he needed a drink, he would only take a small one…He was a neat dresser, and saw to it that his wife was dressed as nicely as himself.*[202]

Kate's affair with Holliday was soon known throughout the West, mostly because the couple kept on the move and always seemed to leave in the wake of a crime, sometimes a killing or even one of their frequent disagreements. Wyatt Earp witnessed several fights between Kate and Holliday, often advising his friend to "belt her one."[203] With and without Earp, the couple made their way from Dodge City to Georgia to Trinidad, Colorado, and Las Vegas, New Mexico. They had been there about two years when Earp showed up in late 1879 and talked Holliday into going with him to Arizona. Kate was not happy about the decision. "I wanted Doc to stay with me. I told Doc that, but Wyatt told him that Arizona was the better place to be."[204]

The ultimate destination of the Earp/Holliday party was Tombstone, but the group needed to see Wyatt's brother Virgil in Prescott first. For unknown reasons, Prescott held no interest for Kate, or if it did, her presence there is undocumented. It is known for sure that Doc remained in Prescott after the Earps left for Tombstone. According to the June 1880 census, he shared a boardinghouse apartment with two other men on Montezuma Street and listed his occupation as a dentist.

Kate may have at least visited on occasion, but when Doc chose to move to Tombstone, she drew the line. Kate later recalled her decision not to accompany the party. "I said to Doc, 'If you are gong to tie yourself to the Earp brothers, go to it. I am going to Globe.'" The couple stayed the night in the town of Gillett, near the Bradshaw Mountains north of Phoenix. Lack of a rooming house forced them to stay in a bed at a mine superintendent's

office. "There was a store there too," Kate remembered, "and we had a kind of a breakfast next morning. We started out again: Doc to Tombstone and I to Globe."[205]

The adventures of Big Nose Kate and Doc Holliday continued for many years, from their presence (and Doc's participation in) the shootout at the O.K. Corral in Tombstone to Doc's 1887 death in Colorado. Although there is no documentation to show that Kate ever did business in Prescott, it is entirely possible that she at least struck fear in the hearts of local harlots when she visited. Largely due to Doc Holliday's reputation, Prescott may not have welcomed her there anyway. In any case, Kate did have the last laugh by appealing to Governor George Hunt in June 1931 for admittance to the Arizona Pioneers Home.

Established in 1911, the Pioneers Home required residents to be natives or longtime citizens of Arizona—and American born at that. Kate was seventy-nine years old and broke. Even with Hunt's assistance, it took her six months, but she was able to reestablish her birthplace as Davenport, Iowa, and was subsequently admitted to the home. By gaining admittance, Kate

Big Nose Kate's grave at the Pioneers Home Cemetery in Prescott. *Jan MacKell Collins.*

achieved more than one victory. Not only was she one of the first women to be admitted, but she also advocated for the comfort of her fellow residents.

Prescott newspapers were politely silent about the infamous Big Nose Kate, who even acquiesced to an extensive interview with Arthur W. Bork in 1935. It was only when she died on November 2, 1940, that a few residents voiced their opinions about the former harlot being buried in a respectable cemetery. But Kate had likely not worked in the prostitution industry since the 1880s, and her friends and admirers stood up for her. Kate's last victory came with her burial at the Arizona Pioneer Home Cemetery in Prescott.

The old red-light district was totally unrecognizable on the Sanborn map by 1948.

Wild Women of Prescott, Arizona

The Firehouse Kitchen and commercial buildings now stand in place of the old Union Saloon. *Jan MacKell Collins.*

In 1947, county attorney David Palmer eliminated prostitution in Prescott once and for all by merely filing various misdemeanor charges against anyone seen going in or out of the Rex Arms, Hazel Rooms on Whiskey Row or any other place where girls were known to sell sex. By 1948, contractor W.J. Henson's construction company occupied much of the area where Ann Hamilton's brothel once stood on South Granite Street. Around this same time, the lots on Granite Street were "cut and leveled" to bring them up to grade. Doing so likely caused the loss of any significant artifacts pertaining to the red-light district's wilder days.[206] Finally, a new firehouse was constructed on the site of the old Union Saloon in about 1955 as Whiskey Row became a quaint tourist destination. By 1971, more new structures appeared along South Granite Street. Today, nobody would be the wiser to the street's former use.

One of the last remnants from Prescott's glory days is the Palace Saloon on Whiskey Row, where visitors can view lots of memorabilia displayed within the building's original interior. The staircase leading to the girls' rooms upstairs is still intact, too. Morris Goldwater, whose soft spot for the wicked ladies and hard-drinking saloons of the past was well known, once commented, "My only regret is that I didn't buy the Palace, when I had a chance."[207]

Rather, the Palace Saloon was purchased by Tom Sullivan 1977. Sullivan, a longtime friend of Goldwater's nephew Barry, quickly penned a note to his friend and assured him that plans were on the table to restore the Palace to its former glory and display historical artifacts for

Wild Women of Prescott, Arizona

The old Palace Saloon still reigns supreme on Whiskey Row. *Jan MacKell Collins.*

South Granite Street as it appears today. *Jan MacKell Collins.*

the public to enjoy. "I know of your very deep and sentimental interest in Prescott," Sullivan wrote, "and…any help that you may be able to give…will be greatly appreciated."[208]

Goldwater wrote back, calling his friend a "rascal" and proclaiming, "You went and bought what had long been my desire to own."[209] Then he acquiesced and told Sullivan some of the more colorful tales from the Palace's bawdy past. Sullivan, unfortunately, never achieved his dream to convert the Palace into a thriving part museum/part saloon. The items and ambience on display today were installed by the current owners during the 1990s. Today, they remain as the final tribute to Prescott and its wicked women.

NOTES

Introduction

1. The original census abstract showed 4,187 people occupying Arizona Territory; however, the Historical Records Survey of 1938 noted the correct number as 4,573. Historical Records Survey, *1864 Census*, vi.

Chapter 1

2. *Prescott Arizona Miner*, April 4, 1868, 3c.2.
3. *Prescott Weekly Arizona Miner*, November 5, 1870.
4. Gail I. Gardner, "Old Whiskey Row" in *Echoes of the Past*, 277.
5. United States Census, 1880.
6. It should be noted that the above story has several versions. Another legend says that the disappearance of the glass eye actually happened when Prescott was attempting to regain the capital from Tucson. In this case, the lady accidentally swallowed the glass eye, which had been deposited in a glass of water when the couple turned in. The eye was never found, and Tucson retained the capital. Brad Courtney, "Did Prescott Lose Capital City Status because of a Stolen Glass Eye?" *Prescott Daily Courier*, November 18, 2012.
7. Sanborn maps of 1890 and 1895 identify all of the buildings in the red-light district as dwellings or boardinghouses. The typical "female boarding,"

signifying a house of prostitution, was not applied here. The draftsman was perhaps unaware that the buildings were being used as such.
8. Lister and Lister, *Chinese Sojourners in Territorial Arizona*, 79.
9. *Prescott Arizona Weekly Journal Miner*, August 1, 1900, 4c.5.
10. Jim Smith, "Prostitution in Arizona, 1870–1935: A Brief History," Sharlot Hall Museum Library & Archives, Prescott, AZ, 76.
11. Gail I. Gardner, "Whiskey Row About the Turn of the Century," *Arizoniana* (Winter 1963). Available in the Sharlot Hall Museum Library & Archives, prostitution file, Prescott, AZ.
12. *Weekly Reflex*, November 19, 1898. Available in the Mayer file, High Desert Heritage Museum Archives, Cordes Lakes, AZ.
13. *Arizona*, June 4, 1978. Available in the Mayer file, High Desert Heritage Museum Archives, Cordes Lakes, AZ.
14. *Arizona Days and Ways Magazine*, December 6, 1964, 40. Available in the Mayer file, High Desert Heritage Museum Archives, Cordes Lakes, AZ.
15. "100 Years Ago," Sharlot Hall Museum Library & Archives, sharlot.org (accessed December 29, 2012).

Chapter 2

16. *Prescott Weekly Arizona Miner*, November 5, 1870. Available in the Sharlot Hall Museum Library & Archives, prostitution file, Prescott, AZ.
17. Susan Lee Johnson, "Women's Households and Relationships in the Mining West: Central Arizona, 1863–1873," unpublished ms., April 1984, 121–22. Available in the Sharlot Hall Museum Library & Archives, prostitution folder, Prescott, AZ.
18. *Weekly Arizona Miner*, March 11, 1871. Available in the Sharlot Hall Museum Library & Archives, prostitution folder, Prescott, AZ.
19. Lister and Lister, *Chinese Sojourners in Territorial Arizona*, 37–38.
20. Foster, Lindley and Ryden, *Celestials and Soiled Doves*, 67.
21. Smith, "Prostitution in Arizona," 75–76.
22. Ann Hibner Koblitz, "'Outcasts' Focuses on Two Communities of 1870s Prescott," *Prescott Daily Courier*, March 6, 2005. Available online at sharlot.org (accessed October 12, 2012).
23. Ruffner, *Prescott*, 64.
24. Traywick, *Frail Prisoners*, 123.
25. "100 Years Ago."
26. Ibid.

27. *Prescott Weekly Journal Miner*, December 11, 1912, 4c.5.
28. Ibid., December 24, 1913, 8c.1.
29. *Prescott Journal Miner*, December 17, 1913, 8c.1, 5.
30. *Weekly Journal Miner*, October 1, 1913, 7c.2; December 17, 1913, 8c.5.
31. Ibid., December 17, 1913, 8c.5.
32. Ibid.
33. For Clara Layton, see Ruffner Funeral Home Records, Sharlot Hall Museum Library & Archives, sharlot.org (accessed December 12, 2012), and Arizona Territorial Board of Health, Bureau of Vital Statistics, Original Certificate of Death, Territorial Index No. 227, County Register RD No. 116; for Cora Knowles, see Arizona Territorial Board of Health, Bureau of Vital Statistics, Original Certificate of Death, Territorial Index No. 206, County Register RD No. 168.
34. "100 Years Ago"; Ruffner Funeral Home Records, Sharlot Hall Museum Library & Archives, sharlot.org (accessed October 16, 2014).
35. "100 Years Ago."
36. Newspaper clipping dated March 14, 1914, Sharlot Hall Museum Library and Archives, prostitution file, Prescott, AZ.
37. Ibid.
38. Ibid.
39. *Weekly Journal-Miner*, April 1, 1914, 6c.6.

Chapter 3

40. *Prescott Miner*, September 17, 1870, 2c.2.
41. Ibid.
42. Ibid.
43. *Prescott Weekly Arizona Miner*, November 5, 1870, 3c.3.
44. *Miner*, February 25, 1871. Available in the Sharlot Hall Museum Library & Archives, prostitution file, Prescott, AZ.
45. *Prescott Miner*, October 25, 1871, 2c.3.
46. *Weekly Arizona Miner*, November 5, 1870, 3c.3.
47. Ibid.
48. Ibid.
49. Ibid.; *Weekly Arizona Miner*, January 7, 1871. Available in the Sharlot Hall Museum Library & Archives, prostitution file, Prescott, AZ.
50. *Weekly Arizona Miner*, November 5, 1870, 3c.3.

51. *Prescott Arizona Journal Miner*, March 8, 1873. Available in the Sharlot Hall Museum Library & Archives, prostitution file, Prescott, AZ.
52. *Prescott Arizona Weekly Journal Miner*, December 27, 1893, 3c.4.
53. Ibid., March 14, 1894, 1c.7.
54. *Globe Daily Arizona Silver Belt*, June 5, 1907, 6c.5.
55. Ibid., October 10, 1908, 1c.1.
56. *Prescott Weekly Journal-Miner*, February 22, 1911, 8c.1.
57. Newspaper clipping dated March 2, 1919, available in the Sharlot Hall Museum Library & Archives, prostitution folder, Prescott, AZ.
58. Ibid., March 26, 1919.

Chapter 4

59. *Victoria F. Behan v. John H. Behan*, Complaint, Section Four, District Court, Yavapai County, Arizona Territory, May 22, 1875, John H. Behan File, Arizona Historical Society; Records of the Clerk of the District Court, Yavapai County, Number 275, Judgment Book 234, 235, 236 in Judgment Docket.
60. Carol Mitchell, "Lady Sadie," http://home.earthlink.net/~knuthco1/recent/LadySadie.htm (accessed October 16, 2014).
61. *Behan v. Behan*.
62. *Prescott Weekly Arizona Miner*, April 5, 1878, 2c.3. Interestingly, a 2004 excavation of Annie Hamilton's brothel, next door to Mollie's, revealed a small porcelain doll head. Did the doll belong to Edith? The truth will likely never be known. Foster, Lindley and Ryden, *Celestials and Soiled Doves*, 107.
63. Only two women didn't get the word that they should mask their true occupations. They were thirty-six-year-old Yow Gum of China, who lived in the alley between South Granite Street and Montezuma Street, and twenty-six-year-old May Mayers, who was born in Germany and lived around the corner from Yow on Goodwin Street.
64. *Flagstaff Coconino Sun*, April 11, 1903, 1c.1.
65. *Kingman Mohave County Miner*, June 19, 1901, 1c.3. In 1903, Blakey and his fellow prospector Roy Winchester were murdered and robbed in Maricopa County. Their killer, James McKinney, was later shot by officers near Bakersfield, California. *Bisbee Daily Review*, April 21, 1903, 1c.6; *Phoenix Arizona Republic*, June 7, 1903, 5c.2.
66. *Arizona Republic*, August 14, 1893, 2c.1.

67. *Prescott Arizona Weekly Journal-Miner*, April 11, 1894, 4c.1.
68. *Prescott Weekly Journal Miner*, July 3, 1909, 4c.3; July 7, 1909, 2c.5.
69. Ibid.; Ruffner Funeral Home Records, Sharlot Hall Museum Library & Archives, sharlot.org (accessed December 13, 2013); Arizona Territorial Board of Health, Bureau of Vital Statistics, Original Certificate of Death, Ter. Index No. 193, County Registered No. 24.
70. Arizona Territorial Board of Health, Bureau of Vital Statistics, Standard Certificate of Death, January 19, 1909.
71. Jan MacKell, "The Black Sheep of El Paso County," Old Colorado History Center newsletter, Colorado Springs, CO, 1993.
72. Although the census taker recorded the women as prostitutes, for some reason he later crossed out their occupations.
73. *Weekly Journal-Miner*, September 4, 1912, 4c.5.

Chapter 5

74. *Prescott Weekly Arizona Miner*, April 25, 1879, 4c.1.
75. Ibid., July 25, 1879, 3c.5.
76. Ibid., May 23, 1884, 1c.7.
77. *Prescott Arizona Weekly Journal-Miner*, May 11, 1887, 3c.2, 3.
78. Ibid., May 18, 1887, 3c.4.
79. Ibid., May 25, 1887, 3c.2.
80. Ibid., July 13, 1887, 3c.7; August 3, 1887, 2c.6.
81. "Deaths and Dispositions," Yavapai County Coroner Inquest #194, Sharlot Hall Museum Library & Archives, sharlot.org (accessed September 24, 2014).
82. *Phoenix Arizona Republican*, July 24, 1895, 5c.1; July 25, 1895, 5c.1.
83. Susan Jones, "The Forgotten Story of 'Diamond May' Ackerman," Sharlot Hall Museum Library & Archives, "Days Past" column, April 4, 2010, sharlot.org (accessed September 23, 2014).
84. News clipping dated August 1, 1896, available in the Sharlot Hall Museum Library & Archives, prostitution folder, Prescott, AZ.
85. *Weekly Journal-Miner*, August 12, 1896, 3c.1.
86. Ibid., November 15, 1899, 3c.1.
87. Because records about her are practically nonexistent, Lydia Carlton may have been confused with Lida Winchell, whose story is illuminated in Chapter 7. For further reference to Ms. Carlton, see Smith, "Prostitution in Arizona," 74–75, and Kitty-Jo Parker Nelson,

"Prescott: Sketch of a Frontier Capitol, 1863–1900," *Arizoniana* 4, no. 4 (Winter 1963): 31.
88. *Bisbee Daily Review*, April 11, 1907, 2c.1.

Chapter 6

89. See "The Wickenburg Massacre, First Authentic Account from an Eye-Witness, Letter from a Wounded Survivor—How Young Loring was Killed—The Attacking Party—A United States Officer's Inhumanity. From Our Own Correspondent, Boston," *New York Times*, Saturday, January 1, 1872, 8. Writer Sandra Mofford Lagesse put the amount at $15,000. Sandra Mofford Lagesse, "A Whodunit Mystery," *Arizona Panoramic Horizons*, azphm.com/azechosarchives.htm (accessed November 12, 2012). Arizona's own state historian, Marshall Trimble, stated the amount was $40,000. Trimble, *Roadside History of Arizona*, 434.
90. Ibid.
91. At Wickenburg, an eighth passenger, Aaron Barnett, joined the stagecoach. Two miles out of town, however, Barnett realized he had forgotten something. Unable to return, Lance stopped so Barnett could disembark and head back to Wickenburg. Lagesse, "A Whodunit Mystery."
92. See "The Wickenburg Massacre." Other historians have identified the time of day as 8:00 a.m., but this may be the time the stage actually departed Wickenburg. Allan Hall, "The Wickenburg Massacre Site—An Enduring Mystery," www.wickenbug-az.com (accessed November 12, 2012).
93. Sandra Mofford Lagesse states that Loring took a "lance to the chest." Lagesse, "A Whodunit Mystery."
94. Allan Hall put the number of robbers pursuing Kruger and Mollie at nine men. Hall, "Wickenburg Massacre Site."
95. "The Wickenburg Massacre."
96. *Arizona State Miner*, "Indian Massacre Mystery of Over Fifty Years Ago," April 18, 1925.
97. Ibid.
98. "The Wickenburg Massacre."
99. Lagesse, "A Whodunit Mystery."
100. "The Wickenburg Massacre."
101. Ibid.

102. The initial exploration of the site also did not include finding the body of William Salmon, who was later found on that same day and buried in a "deep cut in the hillside." Later, certain reports claimed, Salmon was exhumed and reburied alongside the other victims in Wickenburg. Hall, "Wickenburg Massacre Site."
103. Lagesse, "A Whodunit Mystery."
104. Ibid.
105. Allan Hall states that the marker was on Highway 60 and not at the actual massacre site. He also submits through his research that the victims' graves in Wickenburg were "reportedly 'disturbed' in 1949 and then disappeared from local records." Hall, "Wickenburg Massacre Site."
106. On their 1988 excursion to the site, members of the Wickenburg Saddle Club also claimed to have found an area some seventy-five feet east of the graves with a second set of graves containing seven more males, two of whom were believed to be Indians. Also, an abandoned ranch on the way to the site revealed six or seven more graves. "Arizona Pioneer & Cemetery Research Project, Internet Presentation, Wickenburg Massacre," Wickenburg Saddle Cub, http://www.apcrp.org/WICKENBURG_Massacre/Wickenburg_Massacre_Text_071108.htm (accessed November 12, 2012). Allan Hall counted ten graves at the massacre site, far more than the number of victims reported. He also reported six to eight graves at a distance of 50 to 150 yards from the massacre site. Hall, "Wickenburg Massacre Site."

Chapter 7

107. Lida's death certificate states that her mother's maiden name was Addington. Sarah Addington, however, was Lida's grandmother. Lida's mother's name was Sarah Bower. Arizona State Board of Health, Bureau of Vital Statistics, Certificate of Death, State File #434, Registered No. 70B; 1880 Census, Records of the Bureau of the Census, Record Group 29. National Archives, Washington, D.C.
108. *Prescott Evening Courier*, April 5, 1939, 1c.4.
109. *San Antonio Light*, "The Poor Old Woman Whose Death Started a Diamond Rush," June 30, 1940, 56c.2.
110. Claudette Simpson, "Everything You've Always Wanted to Know about the Restricted District but Were Afraid to Ask," *Prescott Courier*, March 12, 1976, 10c.5.
111. *Prescott Evening Courier*, April 5, 1939, 1c.4.

112. Ibid.
113. *San Antonio Light*, "Poor Old Woman."
114. In all other references to Lida's married name, Walter's name appears as "Farrell." Ancestry.com, *Arizona Selected Marriages 1888–1908* [database online], Provo, UT, USA; Certificate of Death, State File #434, Registered No. 70B; 1880 United States Census.
115. *Prescott Weekly Journal-Miner*, November 19, 1913, 5c.5.
116. Ibid.
117. *Graham Guardian*, March 21, 1919, 4c.6; *Bisbee Daily Review*, April 1, 1919, 8c.6.
118. *Prescott Journal-Miner*, August 30, 1916, 3c.5; May 14, 1918, 3c.6; *Prescott City Directory* (Long Beach, CA: Western Directory Co., 1919).
119. Obituary Books, Sharlot Hall Museum Library & Archives, Prescott, AZ, 133.
120. *San Antonio Light*, "Poor Old Woman."
121. *Prescott Evening Courier*, April 5, 1939, 1c.4.
122. Ibid.; Certificate of Death, State File #434, Registered No. 70B.
123. *Prescott Evening Courier*, April 5, 1939, 1c.4.
124. *San Antonio Light*, "Poor Old Woman."
125. Ibid.
126. Simpson, "Everything You've Always Wanted to Know."

Chapter 8

127. *Prescott Journal-Miner*, January 23, 1915, 1c.6.
128. Sam Lowe, "Gabrielle Darley: Murderess or Misunderstood Maiden?" Arizona Oddities, http://arizonaoddities.com/2013/03/gabrielle-darley-murderess-or-misunderstood-maiden (accessed April 20, 2013); unidentified news clipping dated May 15, 1911, Gabriell Wiley estate.
129. Gabe may have meant Dollie, which she later used as her first name. Why she did so remains unknown. *Prescott Weekly Journal-Miner*, June 12, 1912, 5c.1.
130. *Weekly Journal Miner*, May 17, 1911, 3c.6.
131. Ibid.
132. *Morenci (AZ) Copper Era*, January 8, 1915, 7c.5.
133. Leo Banks, "Prescott Prostitute Found Sorted [*sic*] Life Made Fodder for Film," *Prescott Daily Courier*, January 13, 2002. Available in the Sharlot Hall Museum Library & Archives, sharlot.org (accessed November 8, 2012).

134. *Journal-Miner*, January 23, 1915, 1c.6. Other newspapers claimed that staggering to his feet, Topp announced, "Well, I am done" and fell to the floor dead (*Copper Era*, January 8, 1915, 7c.5). Writer Leo Banks claimed Topp actually said, "Well, I guess I'm about through for good." (Banks, "Prescott Prostitute Found.")
135. *Journal-Miner*, January 23, 1915, 1c.6.
136. *Copper Era*, January 8, 1915, 7c.5.
137. Ibid.
138. *Journal-Miner*, January 2, 1915, 6c.3, Gabriell Wiley estate.
139. Banks, "Prescott Prostitute Found"; *Journal-Miner*, January 23, 1915, 1c.6; Leo Banks, "A Madam, A Murder, A Mystery," *Phoenix New Times*, August 12, 1999, phoenixnewtimes.com (accessed October 14, 2014).
140. Ibid.
141. Banks, "Prescott Prostitute Found"; *Journal-Miner*, January 23, 1915, 1c.6.
142. Ibid.
143. *Weekly Journal-Miner*, June 23, 1915, 1c.6.
144. Banks, "A Madam, A Murder, A Mystery."
145. *Weekly Journal-Miner*, December 20, 1922, 2c.1.
146. Banks, "A Madam, A Murder, A Mystery."
147. Leo Banks claimed that in 1927, Bernard S. Melvin was employed as caretaker of the dump outside Prescott when he was severely beaten and robbed of $800 (Banks, "A Madam, A Murder, A Mystery"). Gabe was suspected of orchestrating the incident, but the 1926 *Prescott City Directory* identifies the victim as George Melvin, not Bernard. All that is known for certain is that Melvin was back in California by 1930, living with his sister and her family in Santa Ana and working in a plumbing store (1930 census). He was also briefly admitted to a home for disabled soldiers in 1932 (Historical Register of National Homes for Disabled Volunteer Soldiers, 1866–1938, Records of the Department of Veterans Affairs, National Archives, Washington, D.C.). Nothing else of note happened to Melvin until his death in Los Angeles in 1968 (Ancestry.com. *California, Death Index, 1940–1997*).
148. Undated news clipping, Gabriell Wiley estate.
149. Ibid.
150. Banks, "Prescott Prostitute Found."
151. Ibid.
152. Ibid.
153. Ibid.

154. Court of Appeal of California, Fourth District, https://casetext.com/case/melvin-v-reid (accessed October 14, 2014).
155. Ibid.
156. Ruffner Funeral Home records, Sharlot Hall Museum & Library Archives, sharlot.org (accessed September 13, 2014); Arizona State Board of Health, Bureau of Vital Statistics, Standard Certificate of Death, State File No. 80, Registered No. 243.
157. Banks, "A Madam, A Murder, A Mystery."
158. Brusco interview, November 15, 2014.
159. It has been noted that Gabe felt the need to check the pockets of her gentlemen friends as they left to make sure they took home nothing more than full stomachs and good memories. John Brusco Jr. would also help her count the silverware afterward but speculated that it was more of a habit than mistrust of her friends. Banks, "A Madam, A Murder, A Mystery"; Brusco interview.
160. Ruffner correspondence, November 2014.
161. Banks, "A Madam, A Murder, A Mystery."
162. Brusco interview, November 15, 2014; December 5, 2014.
163. Banks, "A Madam, A Murder, A Mystery."

Chapter 9

164. Koblitz, "Outcasts."
165. *Prescott Arizona Miner*, February 15, 1873, 3c.1.
166. Some say this may have occurred as early as 1877. Available in Sharlot Hall Museum Library & Archives, prostitution folder, Prescott, AZ. For 1887 statutes, see "Chapter VIII, #529," *Revised Statues of Arizona* (Prescott, AZ: Prescott Courier Print, 1887), 715.
167. *Tucson (AZ) Weekly Citizen*, February 28, 1891, 2c.3.
168. Ibid.
169. Miscellaneous news clipping, available in Sharlot Hall Museum Library and Archives, prostitution file, Prescott, AZ.
170. "Rape, Abduction, Carnal Abuse of Children and Seduction," in *Revised Statutes of Arizona* (Columbia, MO: Press of E.W. Stephens, 1901), 1226–27.
171. Ibid., 291.
172. Smith, "Prostitution in Arizona," 77.
173. Ibid., 77–78.

174. Ibid., 78.
175. Ibid.
176. "An Act to Suppress Lewdness in Saloons," January 23, 1907, available in Sharlot Hall Museum Library & Archives, prostitution folder, Prescott, AZ.
177. Gail I. Gardner, "Whiskey Row About the Turn of the Century," *Arizoniana* (Winter 1963): 25.
178. "An Act to Suppress Lewdness in Saloons."
179. *Phoenix Arizona Republic*, May 11, 1910, 15c.
180. *Prescott Weekly Journal-Miner*, June 12 1912, 5c.1; June 19, 1912, 5c.2.
181. Ibid.
182. Ibid.
183. *Weekly Journal-Miner*, June 19, 1912, 5c.2.
184. *Prescott Arizona Weekly Miner-Journal*, March 26, 1913, 4c.6. Judge Smith's decree likely did not apply to prostitutes who kept "ceremonial" husbands.
185. Ibid.
186. *Prescott Journal Miner*, August 16, 1913, 1c.2.
187. Ibid.
188. Roosevelt Memorial Association, *Cyclopedia of Temperance*, 3.
189. Newspaper clipping dated February 16, 1918, available in Sharlot Hall Museum Library & Archives, prostitution file, Prescott, AZ.
190. Ibid.
191. Newspaper clippings dated March 25 and 26, 1919, available in Sharlot Hall Museum Library & Archives, prostitution file, Prescott, AZ.
192. Newspaper clipping dated May 18, 1928, available in Sharlot Hall Museum Library & Archives, prostitution file, Prescott, AZ.
193. Ruffner correspondence, November 9, 2014.
194. Ibid.
195. Ibid.

Chapter 10

196. Notably, Joss House—Prescott's infamous Chinese temple—was now identified as a "Labor Temple" in the city directory. *Prescott City Directory 1923* (Long Beach, CA: Western Directory Company, 1923).
197. Foster, Lindley and Ryden, *Celestials and Soiled Doves*, 77.
198. Arizona State Board of Health, Bureau of Vital Statistics, Standard Certificate of Death, State File No. 418, Registered No. 239G; Ruffner

Funeral Home Records, Sharlot Hall Museum Library & Archives, sharlot.org (accessed December 29, 2012).
199. Ruffner Funeral Home Records.
200. Foster, Lindley and Ryden, *Celestials and Soiled Doves*, 7.
201. Tanner, *Doc Holliday*, 110.
202. Ibid., 225–26.
203. Enss, *Pistol Packin' Madams*, 53.
204. Chartier and Enss, *Love Untamed*, 84.
205. Tanner, *Doc Holliday*, 142–44.
206. Foster, Lindley and Ryden, *Celestials and Soiled Doves*, 31.
207. Brad Courtney, "Did Prescott Lose Capital City Status Because of a Stolen Glass Eye?" *Prescott Daily Courier*, sharlot.org (accessed November 18, 2012).
208. Ibid.
209. Ibid.

Bibliography

Books

Acts, Resolutions and Memorials of the Twenty-Fourth Legislative Assembly of the Territory of Arizona. Phoenix, AZ: H.H. McNeil Company, 1907.

Chartier, JoAnn, and Chris Enss. *Love Untamed: Romances of the Old West.* Guilford, CT: Twodot, 2002.

Enss, Chris. *Pistol Packin' Madams: True Stories of Notorious Women of the Old West.* Helena, MT: Twodot, 2006.

Foster, Michael S., John M. Lindley and Ronald F. Ryden. *Celestials and Soiled Doves: The Archaeology and History of Lots 4–9, Block 13 of Historic Prescott's Original Townsite: The Prescott City Centre Project.* SWCA Cultural Resource Report No. 03-386, March 2004.

Heatwole, Thelma. *Ghost Towns and Historical Haunts in Arizona.* Phoenix, AZ: Golden West Publishers, 1981.

Kirschner, Ann. *Lady at the O.K. Corral.* New York: Harper Collins, 2013.

Lister, Florence C., and Robert H. Lister. *Chinese Sojourners in Territorial Arizona. Prescott, Arizona.* Prescott, AZ: Sharlot Hall Museum, 2002.

MacKell, Jan. *Brothels, Bordellos & Bad Girls: Prostitution in Colorado, 1860–1930.* Albuquerque: University of New Mexico Press, 2003.

———. *Cripple Creek District: Last of Colorado's Gold Booms.* Charleston, SC: Arcadia Publishing, 2003.

———. *Red-Light Women of the Rocky Mountains.* Albuquerque: University of New Mexico Press, 2003.

Bibliography

Monahan, Sherry. *Mrs. Earp: The Wives and Lovers of the Earp Brothers.* Guilford, CT: Globe Pequot Press, 2013.

Quebbeman, Frances E. *Medicine in Territorial Arizona.* Phoenix: Arizona Historical Foundation, 1966.

Revised Statues of Arizona. Phoenix, AZ: McNeil Co., 1913.

Roosevelt Memorial Association. *The Cyclopedia of Temperance, Prohibition and Public Morals.* Edited by Deets Pickett. New York: Methodist Book Concern, 1917.

Ruffner, Melissa. *Prescott: A Pictorial History.* 4th ed. Prescott, AZ: Primrose Press, 1994.

Spude, Robert L., and Stanley W. Paher. *Central Arizona Ghost Towns.* Las Vegas: Nevada Publications, 1978.

Steele, Volney. *Bleed, Blister and Purge.* Missoula, MT: Mountain Press Publishing, 2005.

Tanner, Karen Holliday. *Doc Holliday: A Family Portrait.* Norman: University of Oklahoma Press, 1998.

Traywick, Ben T. *Frail Prisoners in Yuma Territorial Prison.* Tombstone, AZ: Red Marie's Bookstore, 1997.

Trimble, Marshall. *Roadside History of Arizona.* Missoula, MT: Mountain Press Publishing Company, 2004.

Walker, Henry P., and Don Bufkin. *Historical Atlas of Arizona.* 3rd ed. Norman: University of Oklahoma Press, 1983.

Wilson, R. Michael. *Massacre at Wickenburg: Arizona's Greatest Mystery.* Guilford, CT: TwoDot, Globe-Pequot Press, 2007.

Writer's Program of the Work Projects Administration. *Arizona: A State Guide.* New York: Hastings House, 1940.

Yavapai Cowbelles of Arizona. *Echoes of the Past: Tales of Old Yavapai.* Edited by Robert C. Stevens. Prescott, AZ: Yavapai Cowbelles of Arizona, 1955, 1964.

Census

Historical Records Survey, Division of Women's and Professional Projects, Works Progress Administration. *The 1864 Census of the Territory of Arizona.* Phoenix, AZ, 1938.

United States Census Records, 1860–1940.

Bibliography

Documents

United States Department of the Interior. National Register of Historic Places Registration. "Mayer Apartments," June 12, 1989. Entered July 13, 1989.

Internet

Ancestry.com.
"BJ's Tombstone History Discussion Forum." http://disc.yourwebapps.com.
Findagrave.com.
"*Red Kimono*." Movie Diva. http://www.moviediva.com.
Stanley, John. "Wickenburg Massacre: Who Really Did It?" AZCentral.com.
"Wickenburg Massacre." Historical Marker Database. hmdb.org.

Interviews

John Murray, October 8, 2014, Dewey, AZ.
John and Mary Jo Murray, October 11, 2014, Dewey, AZ.
Tim Wellesley (correspondence), November 2014.

Newspapers

Arizona

Arizona Journal Miner
Arizona Republic
Arizona State Miner
Arizona Weekly Citizen
Arizona Weekly Journal Miner
Bisbee Daily Review
Coconino Sun
Copper Era
Daily Arizona Silver Belt
Daily Courier
Miner
Mohave County Miner

Bibliography

Prescott Evening Courier
St. Johns Herald
Tombstone Epitaph
Weekly Arizona Miner
Weekly Journal-Miner
Weekly Reflex

Other

Los Angeles Herald
Los Angeles Times
New York Times

About the Author

Jan MacKell Collins writes about prostitution history and other interesting aspects of the West. She is formerly the director of the Cripple Creek District Museum and the Old Homestead Museum in Cripple Creek, Colorado. She also had the pleasure of working for Sharlot Hall Museum in Prescott, Arizona. In addition, Ms. Collins has written over two thousand western history articles for magazines in Colorado, Montana and Arizona, including *True West* magazine. In 2010, she was nominated for Women Writing the West's WILLA award for her 2009 book, *Red-light Women of the Rocky Mountains*; also, she was a co-nominee in 2011 for the 2010 anthology *Extraordinary Women of the Rocky Mountain West*. In addition to her writing, Ms. Collins has given over forty programs on the subject of prostitution and western history and has been featured on Rocky Mountain PBS.

Visit us at
www.historypress.net

This title is also available as an e-book